In the Mind's Eye

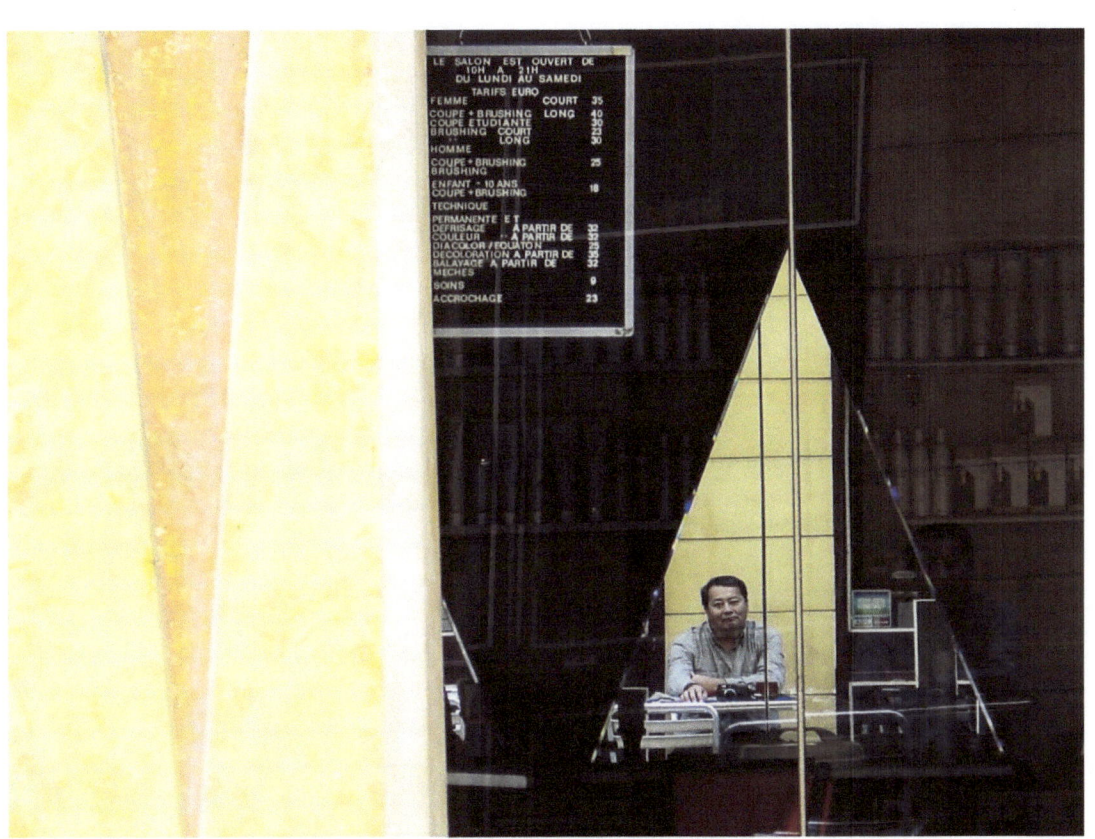

Art Shimamura

Copyright © 2017 by Arthur Shimamura.

All rights reserved. No part of this book may be reproduced in any form or by any electronic or mechanical means, including information storage and retrieval systems, without permission in writing from the publisher.

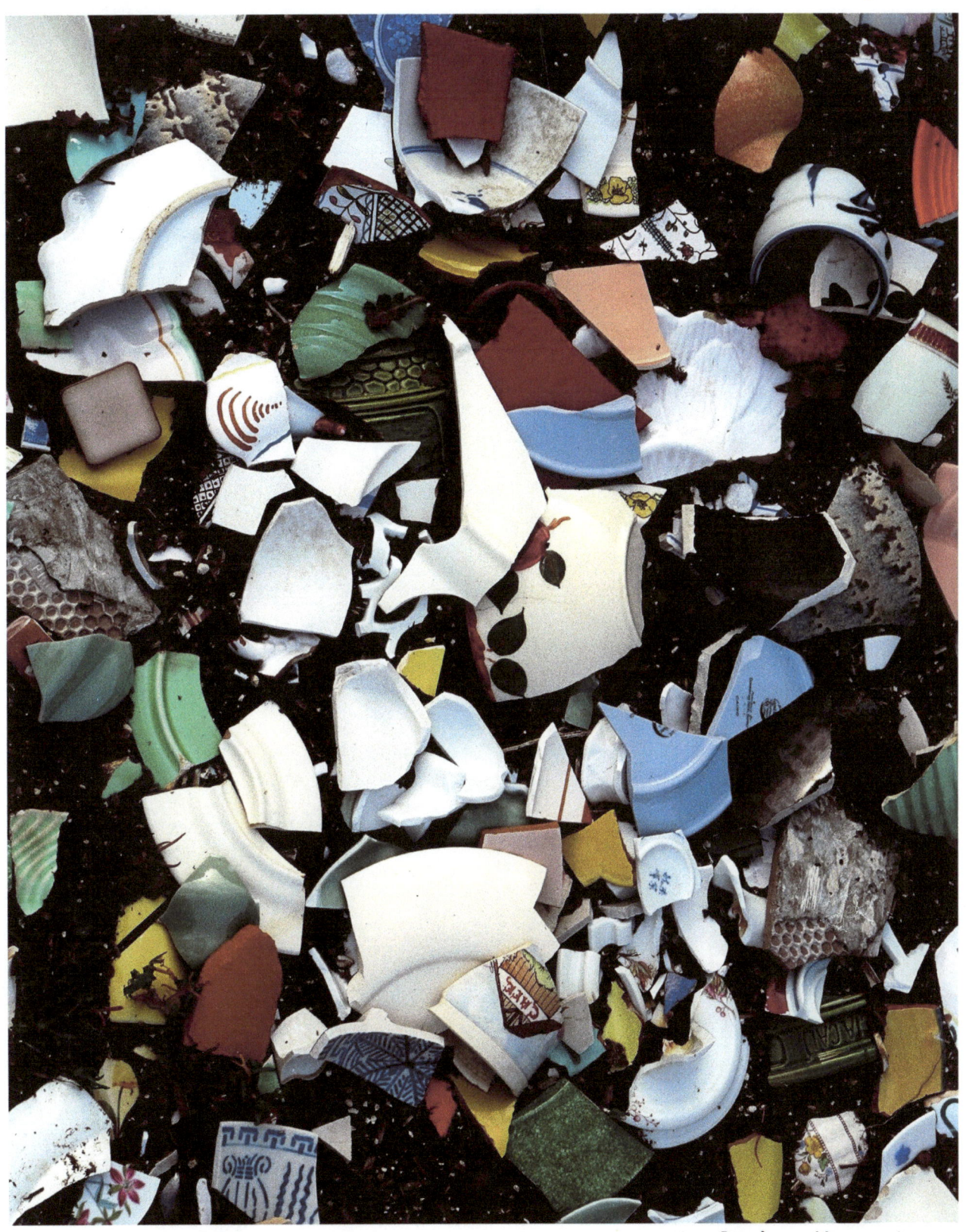

Broken Memories

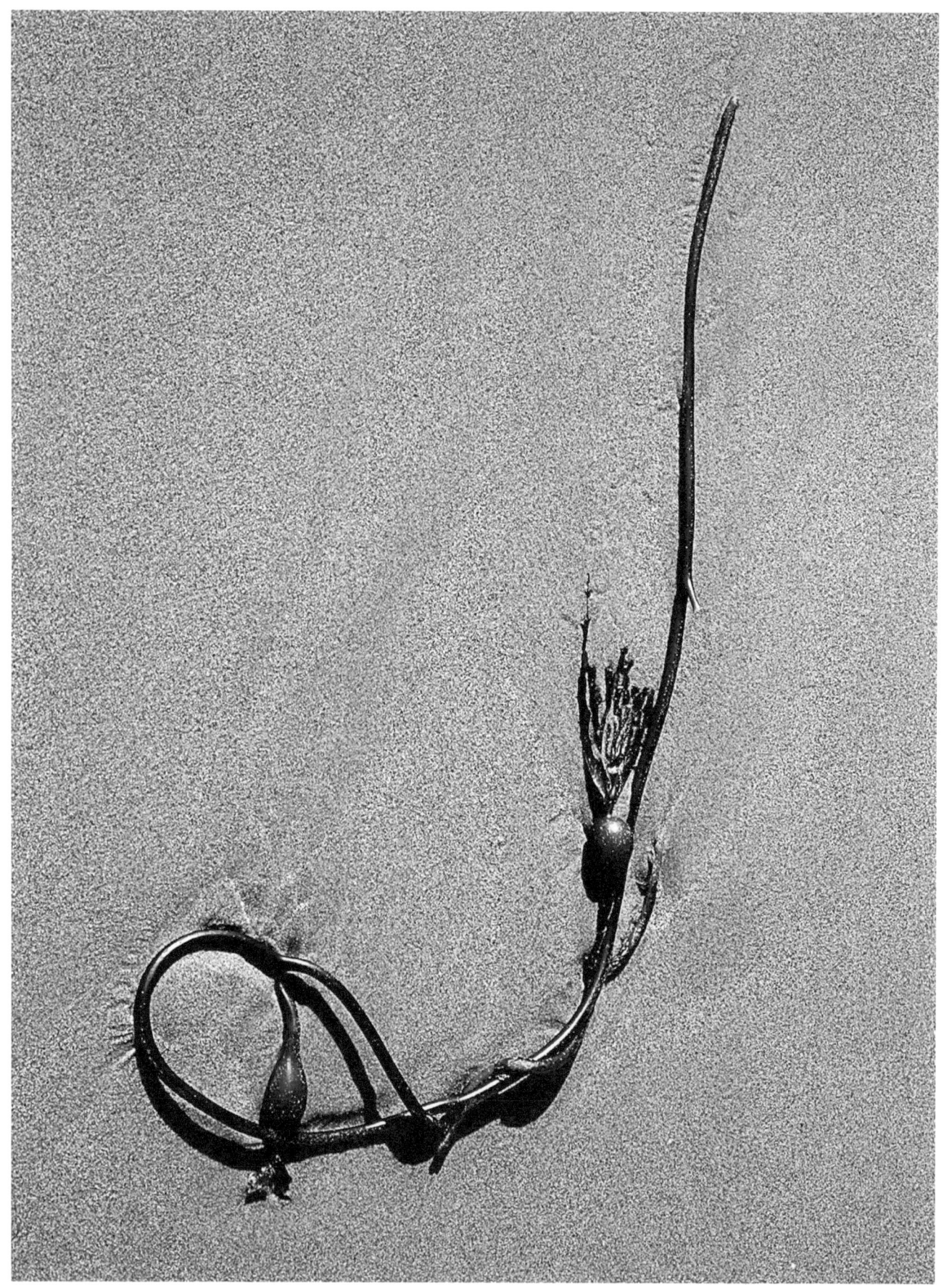

Kelp I

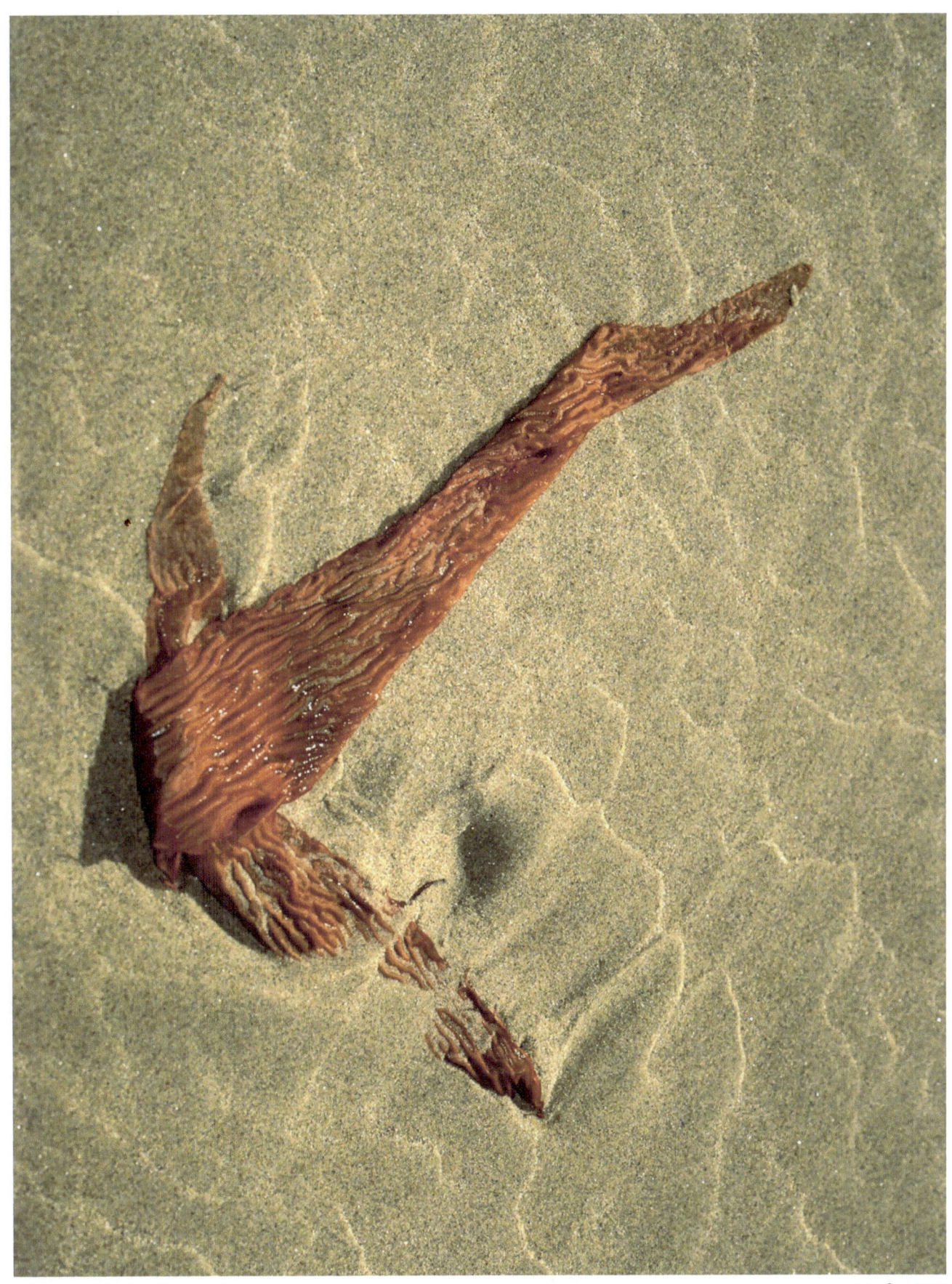

Kelp II

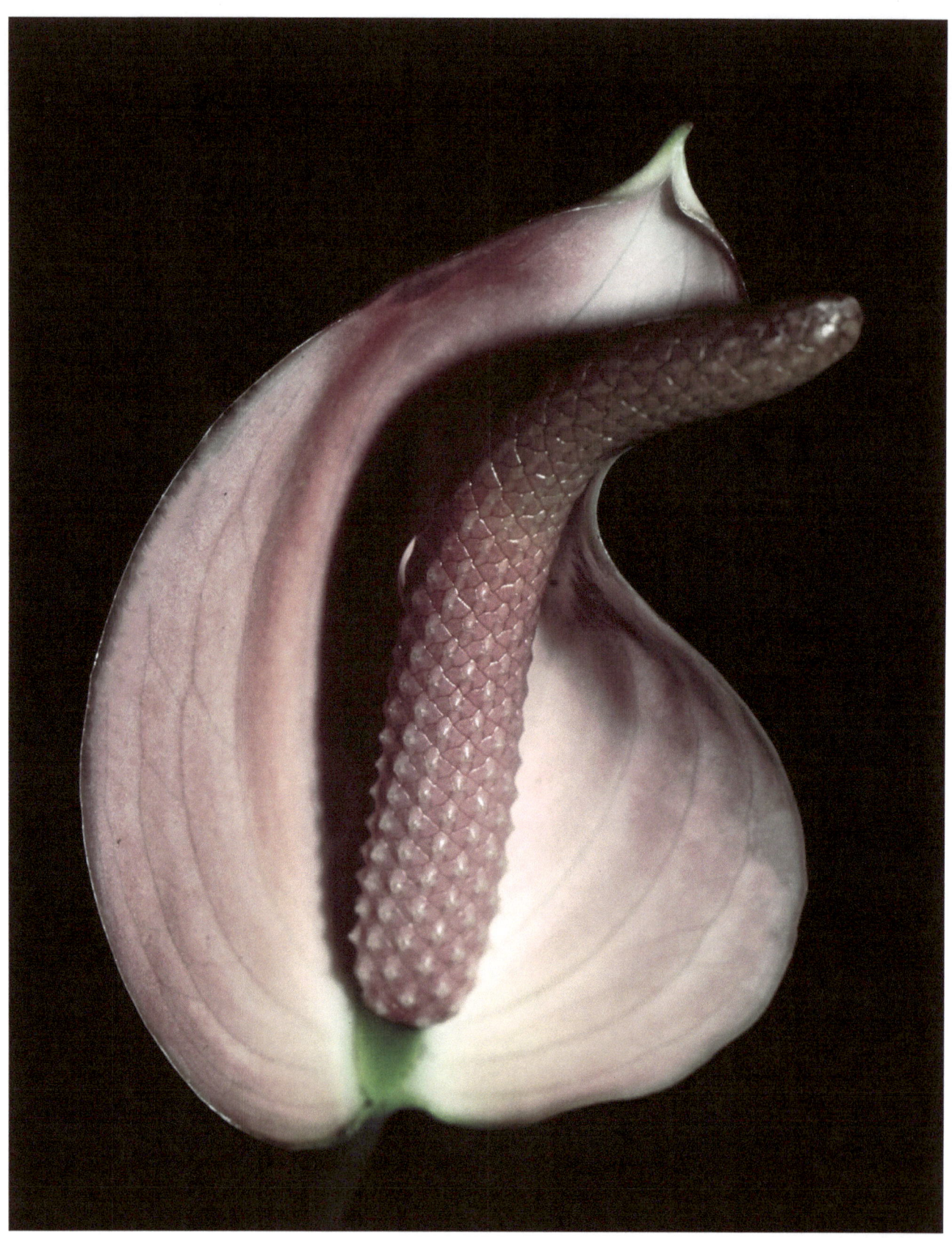

Anthurium

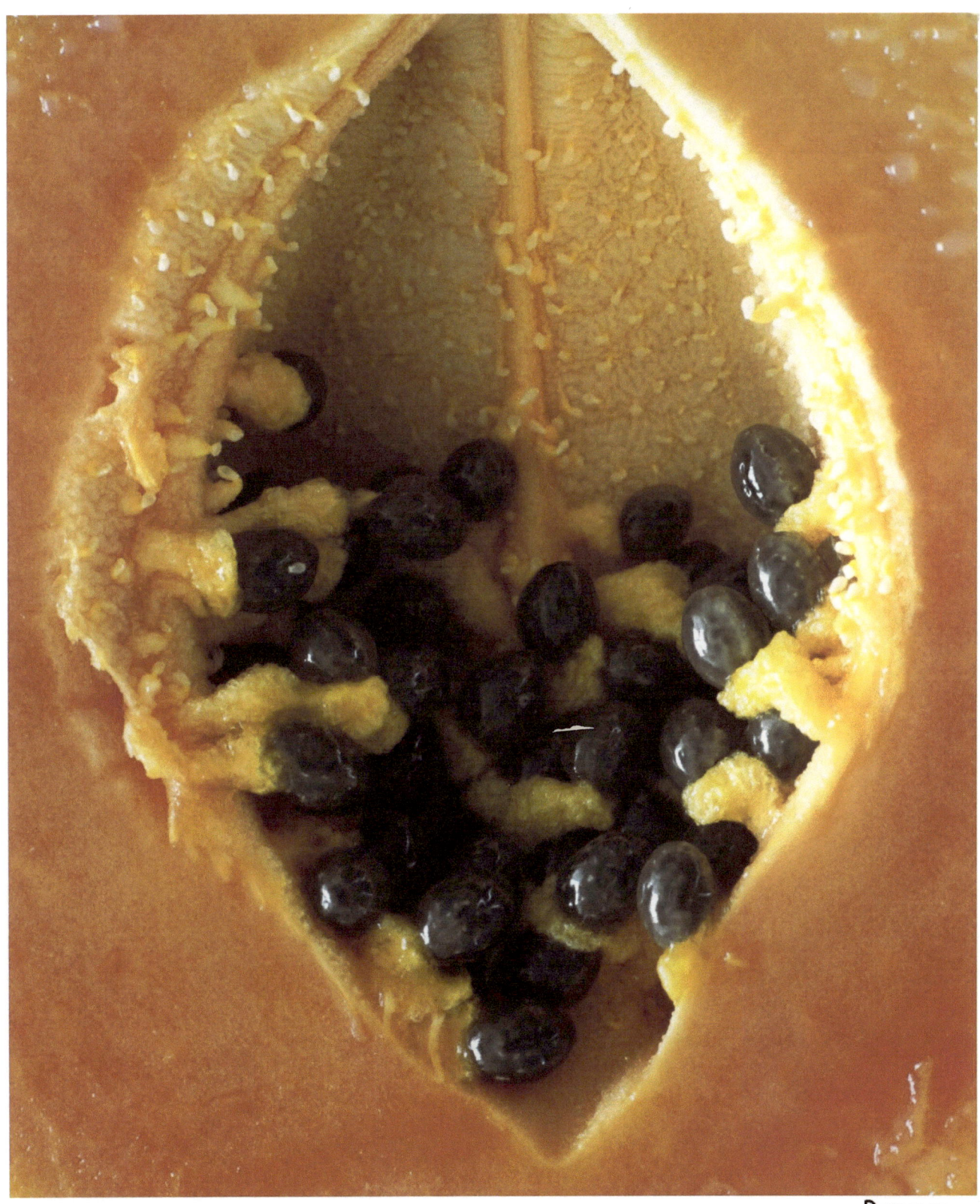

Papaya

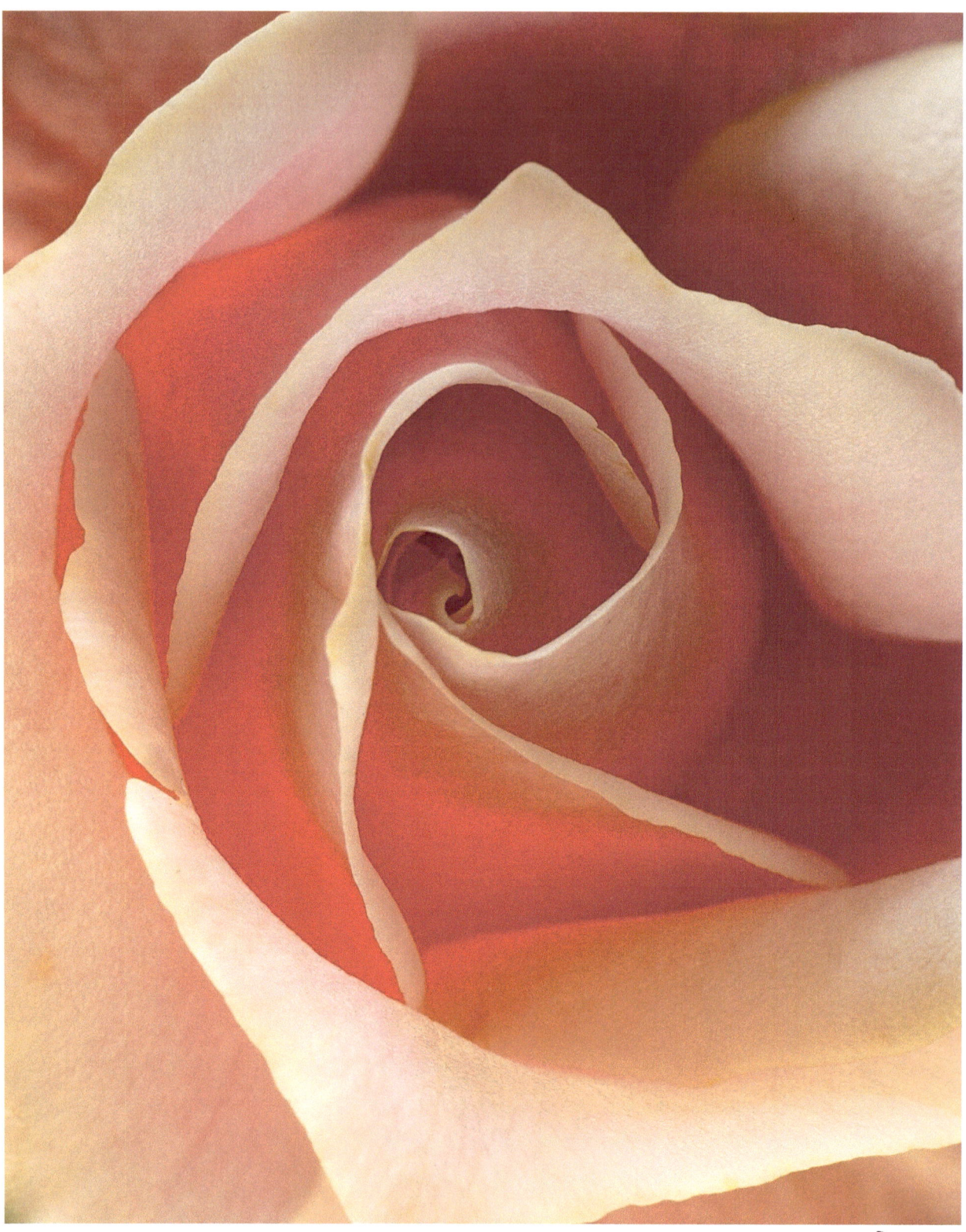

Rose

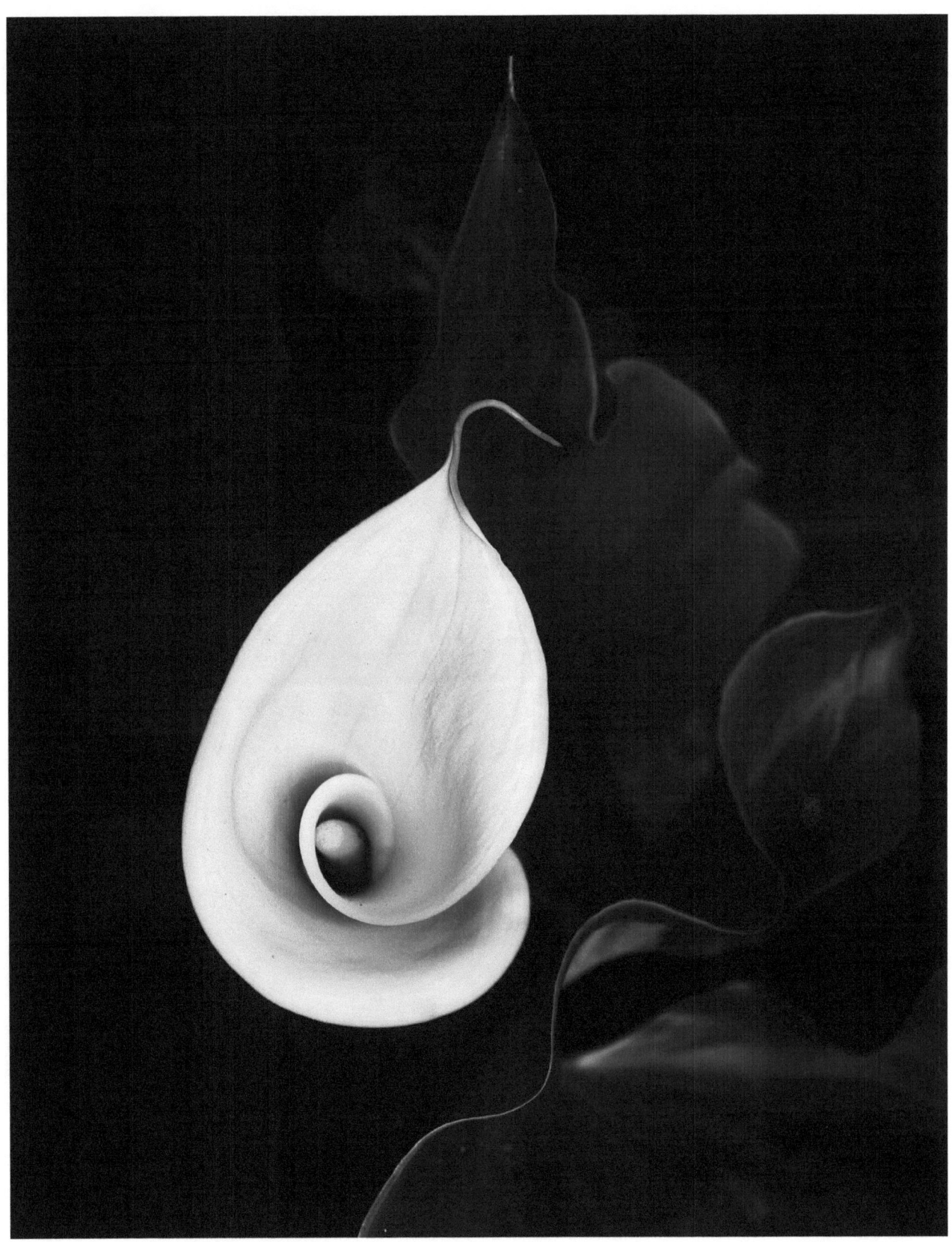

Calla Curves

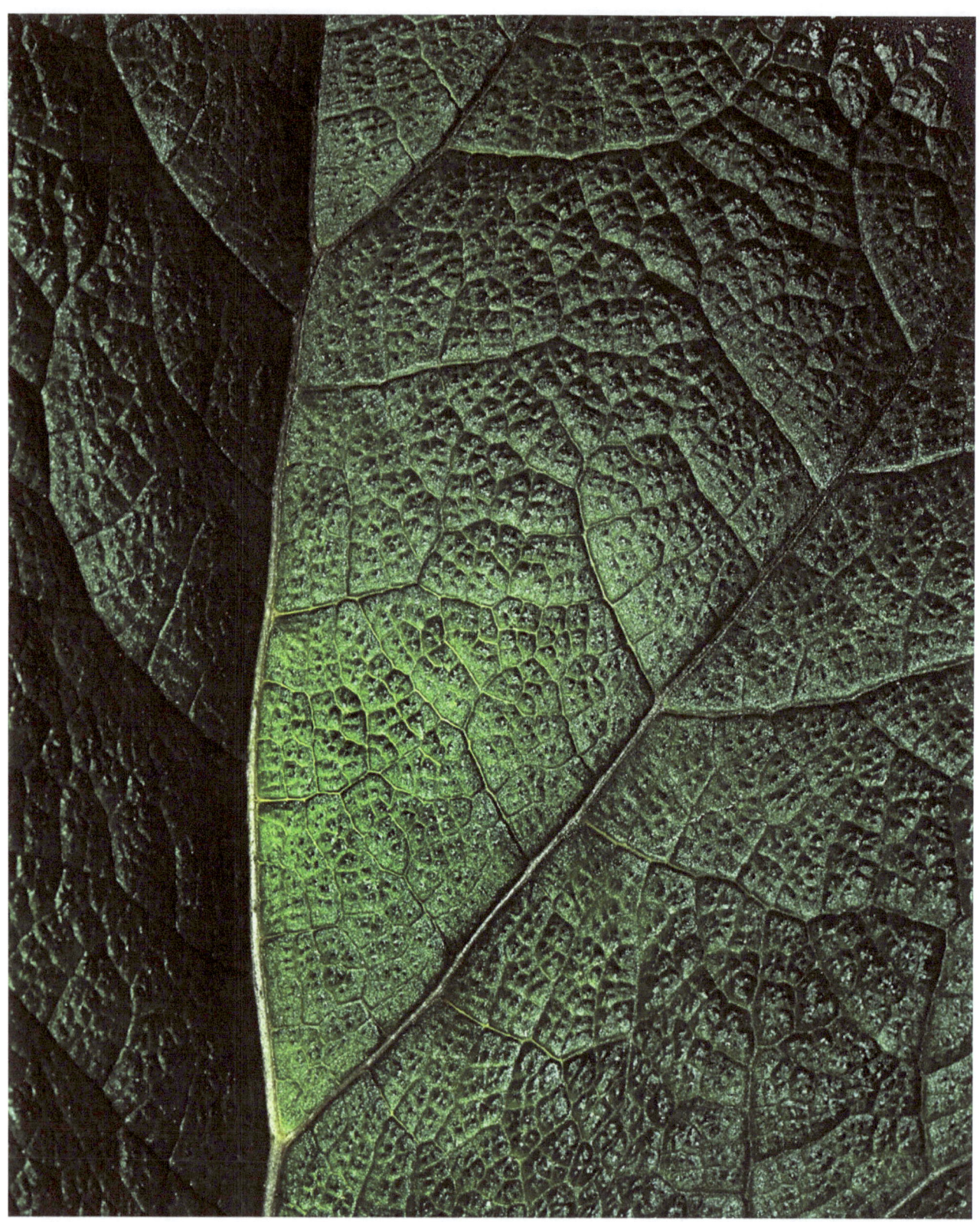

Leaf Abstract

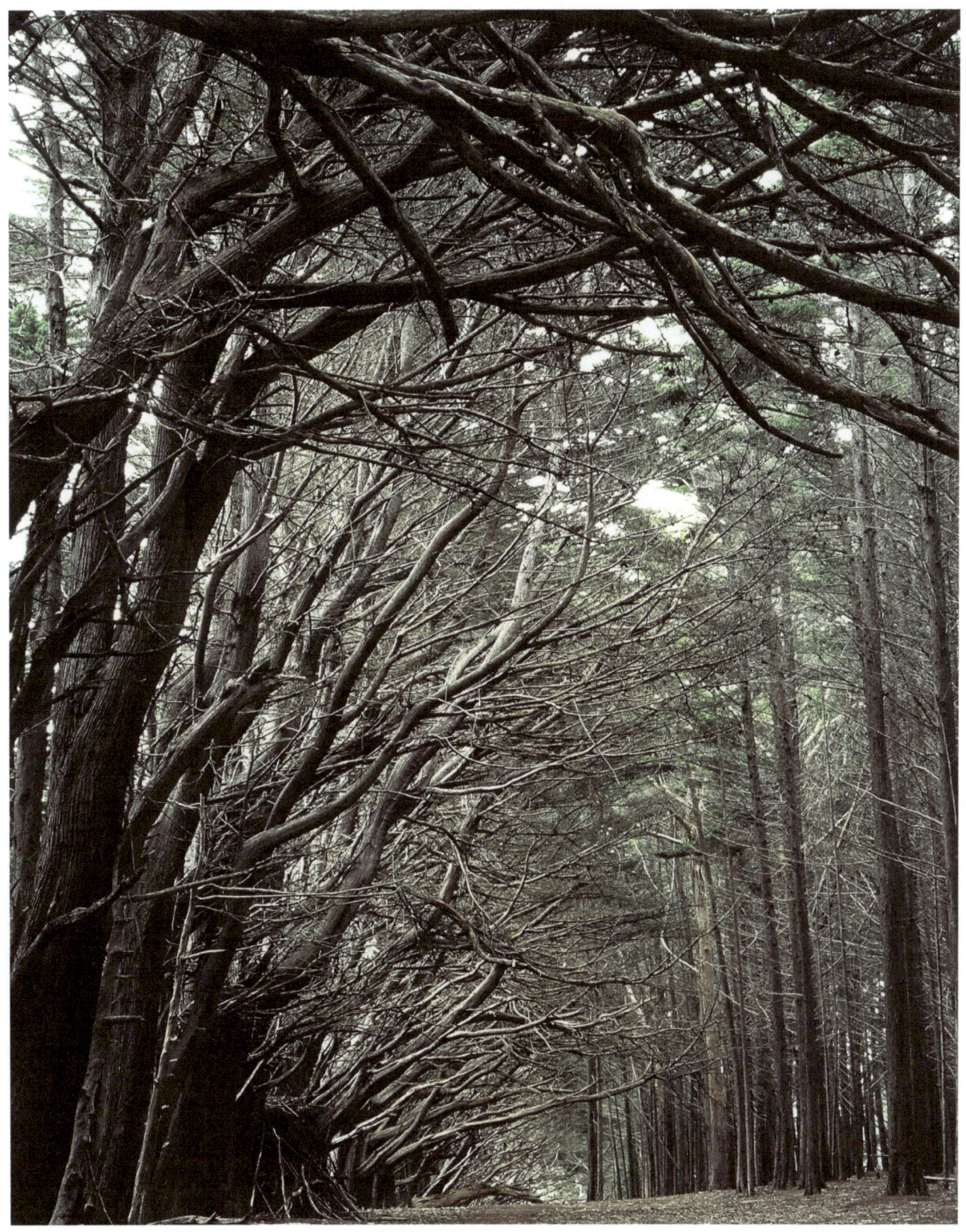

Tree Lane

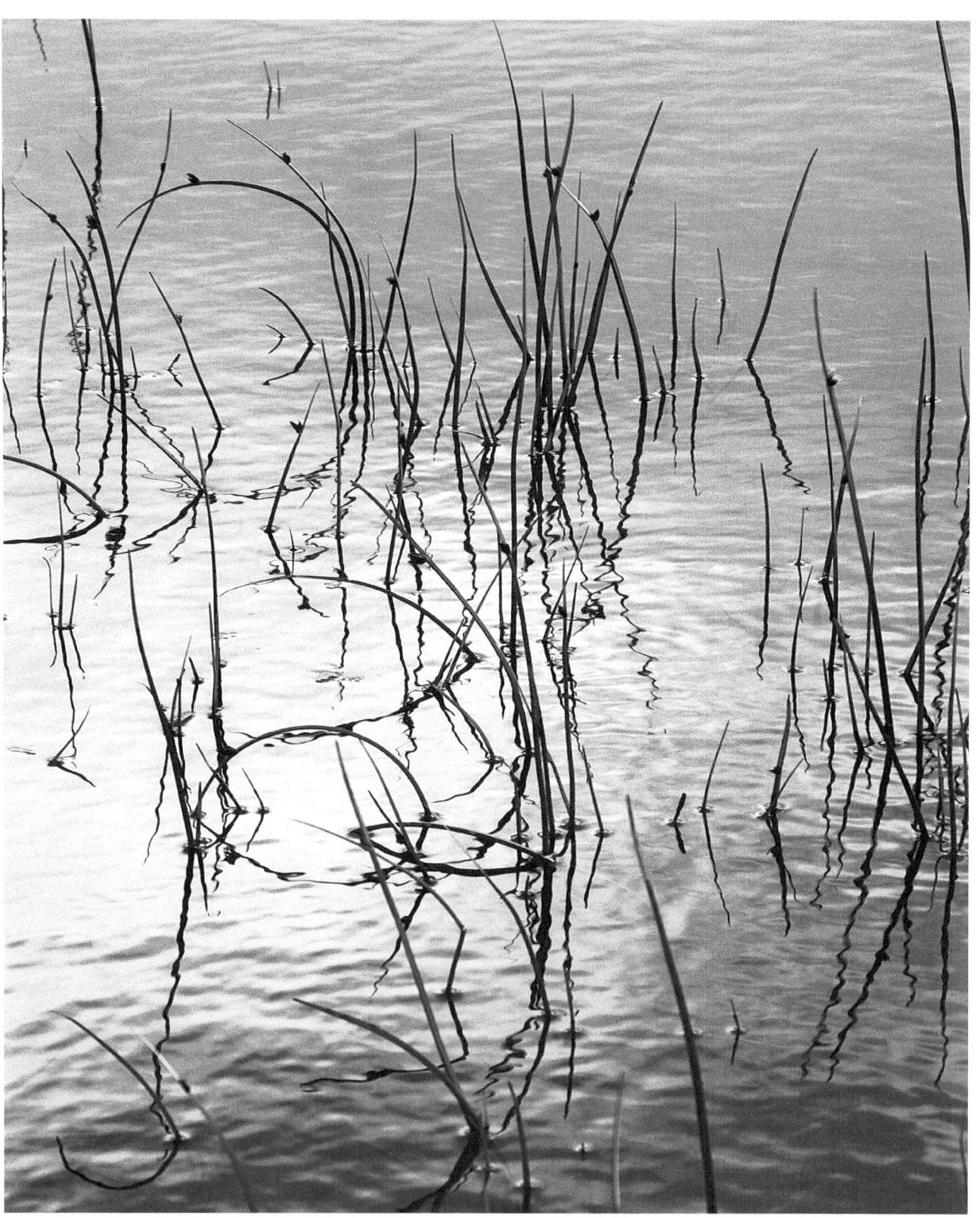

Reeds

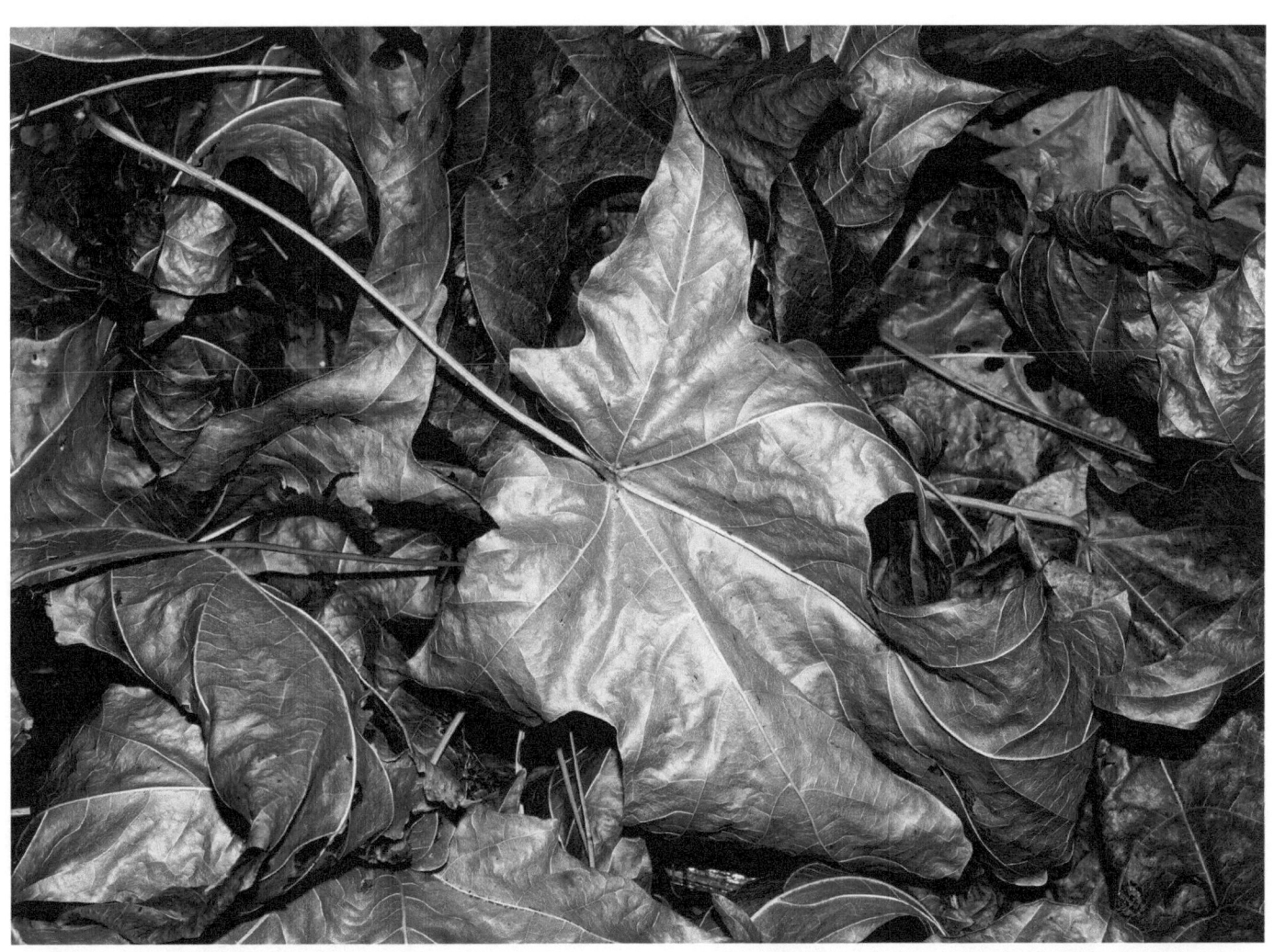

Autumn Leaves

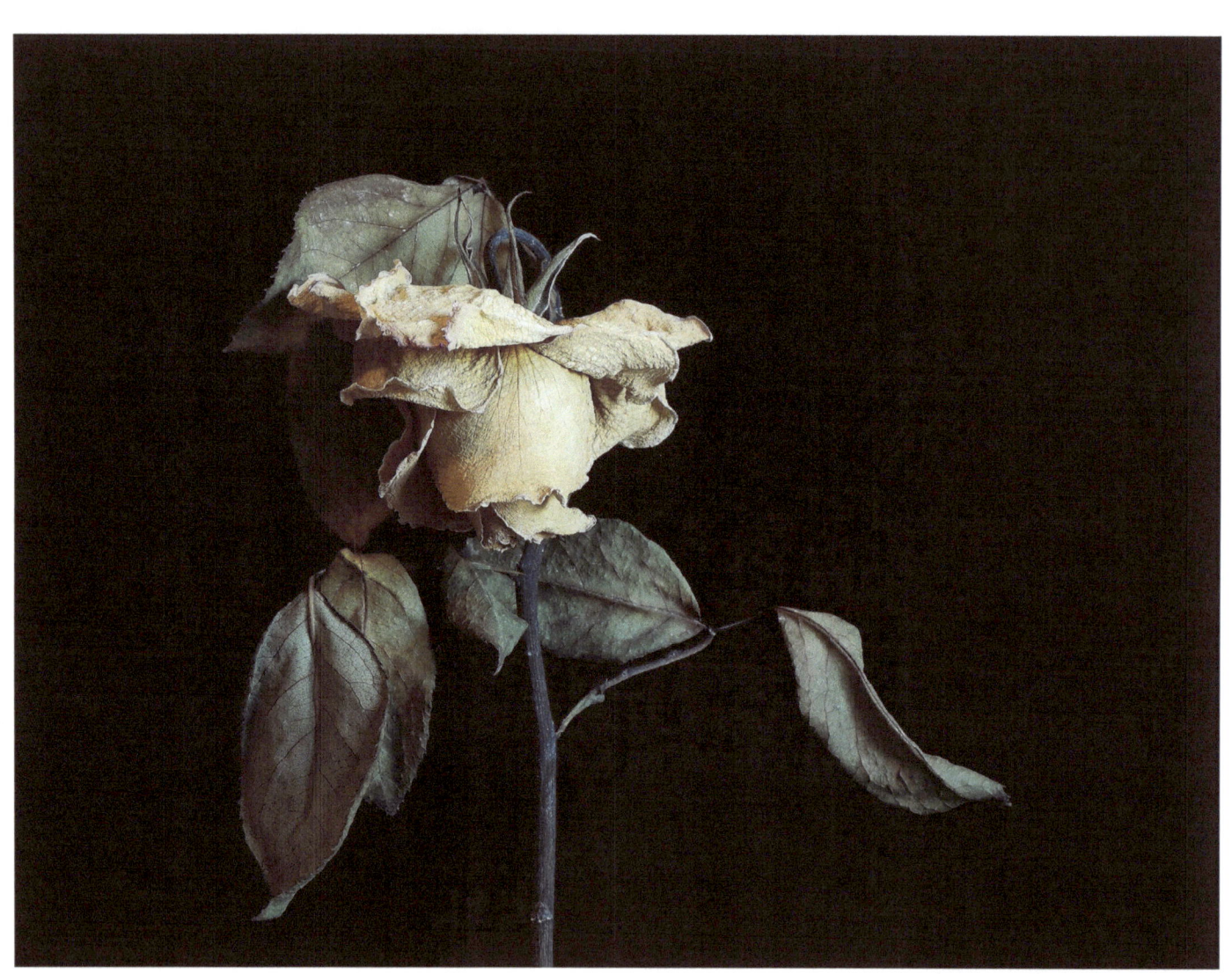

Gracefully Aging

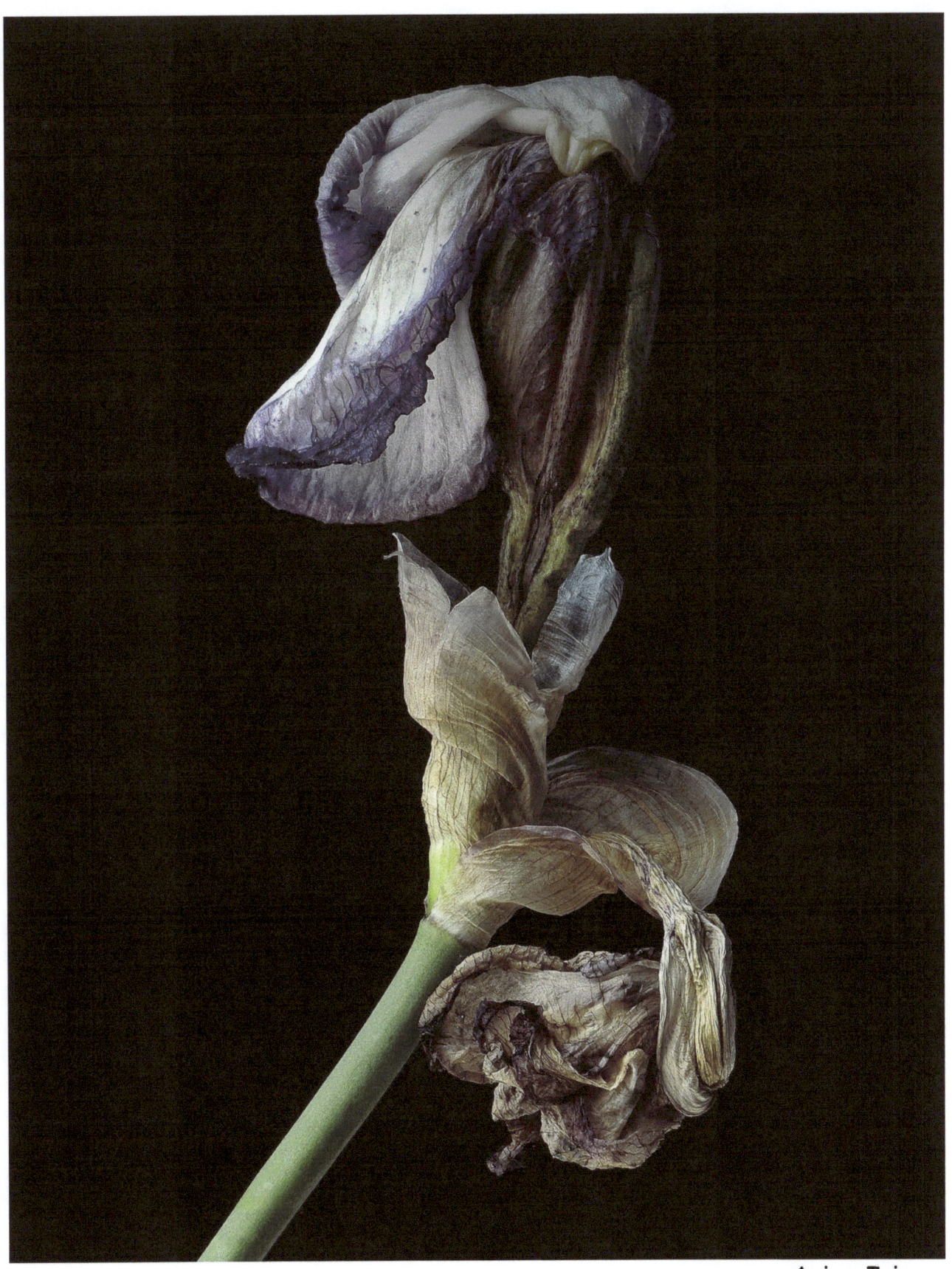

Aging Iris

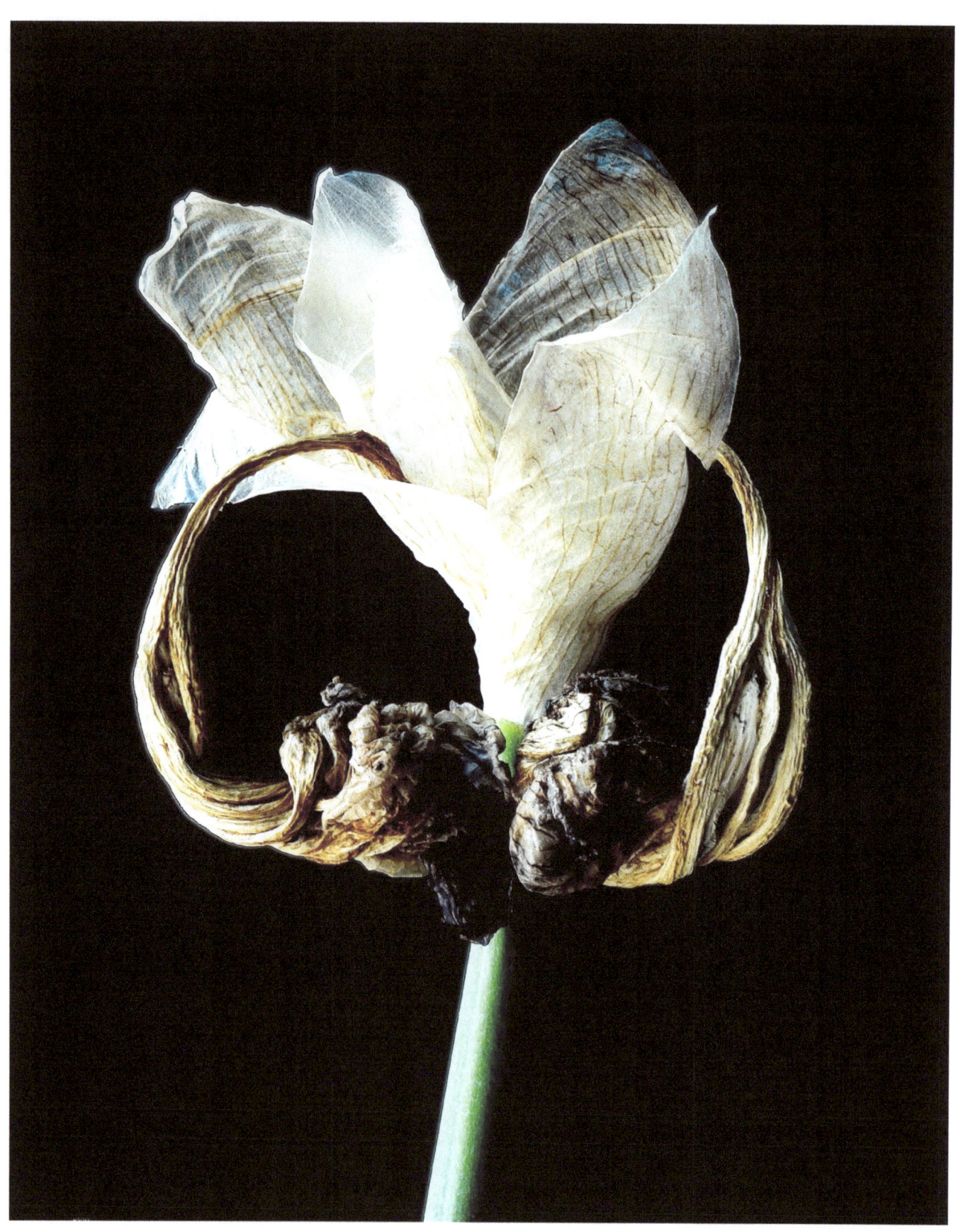

Aging Curl

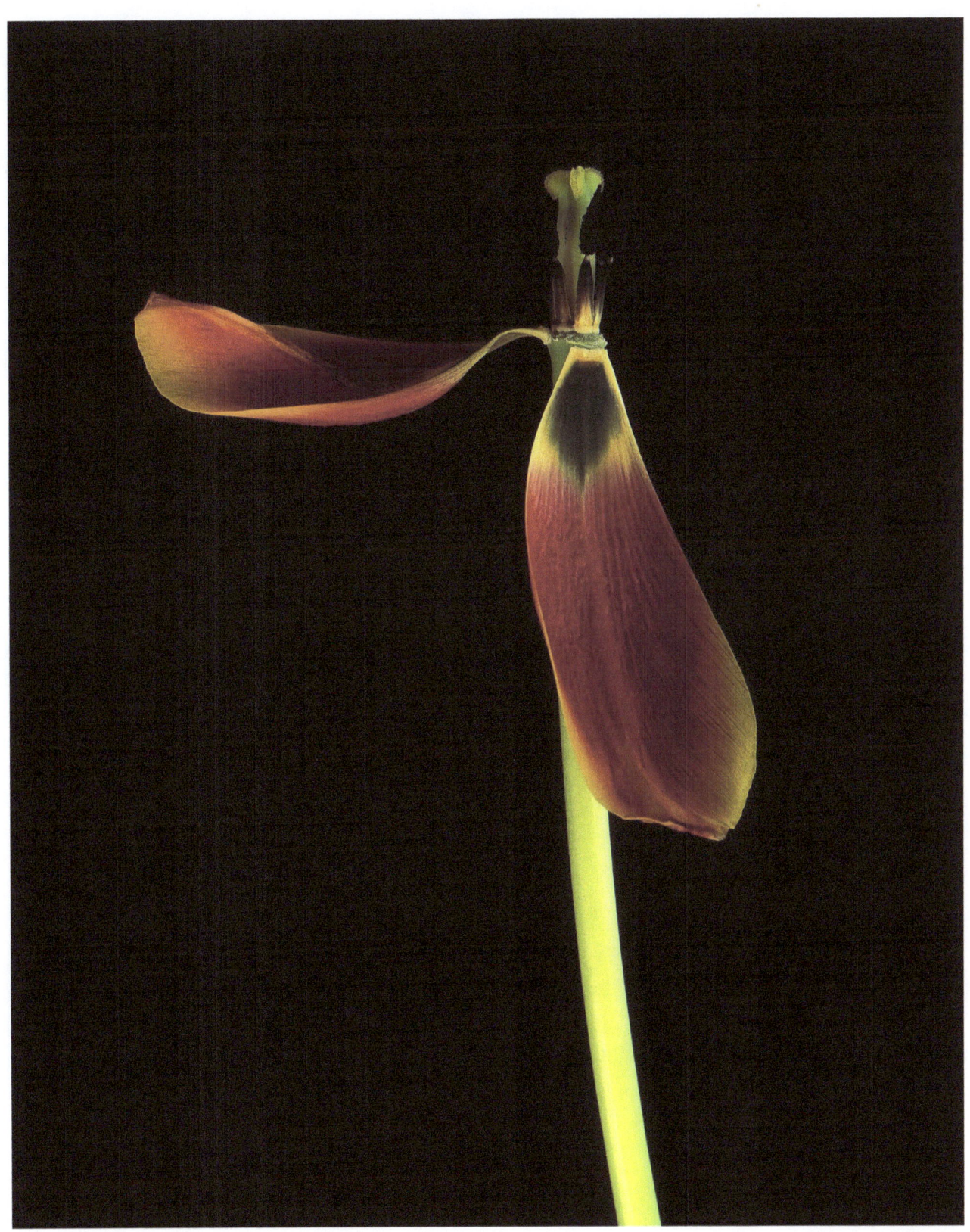

Aging Tulip

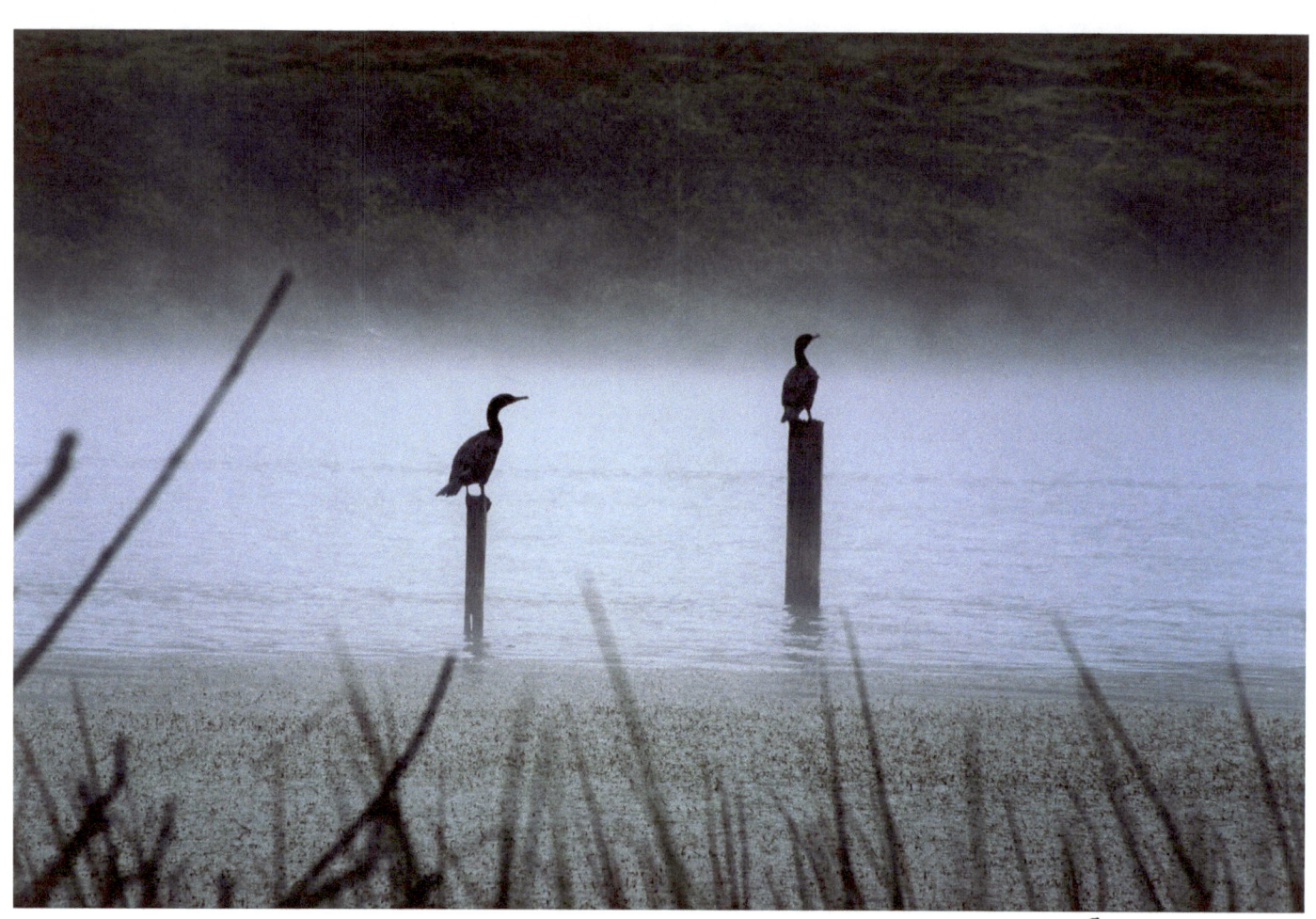

Cormorants

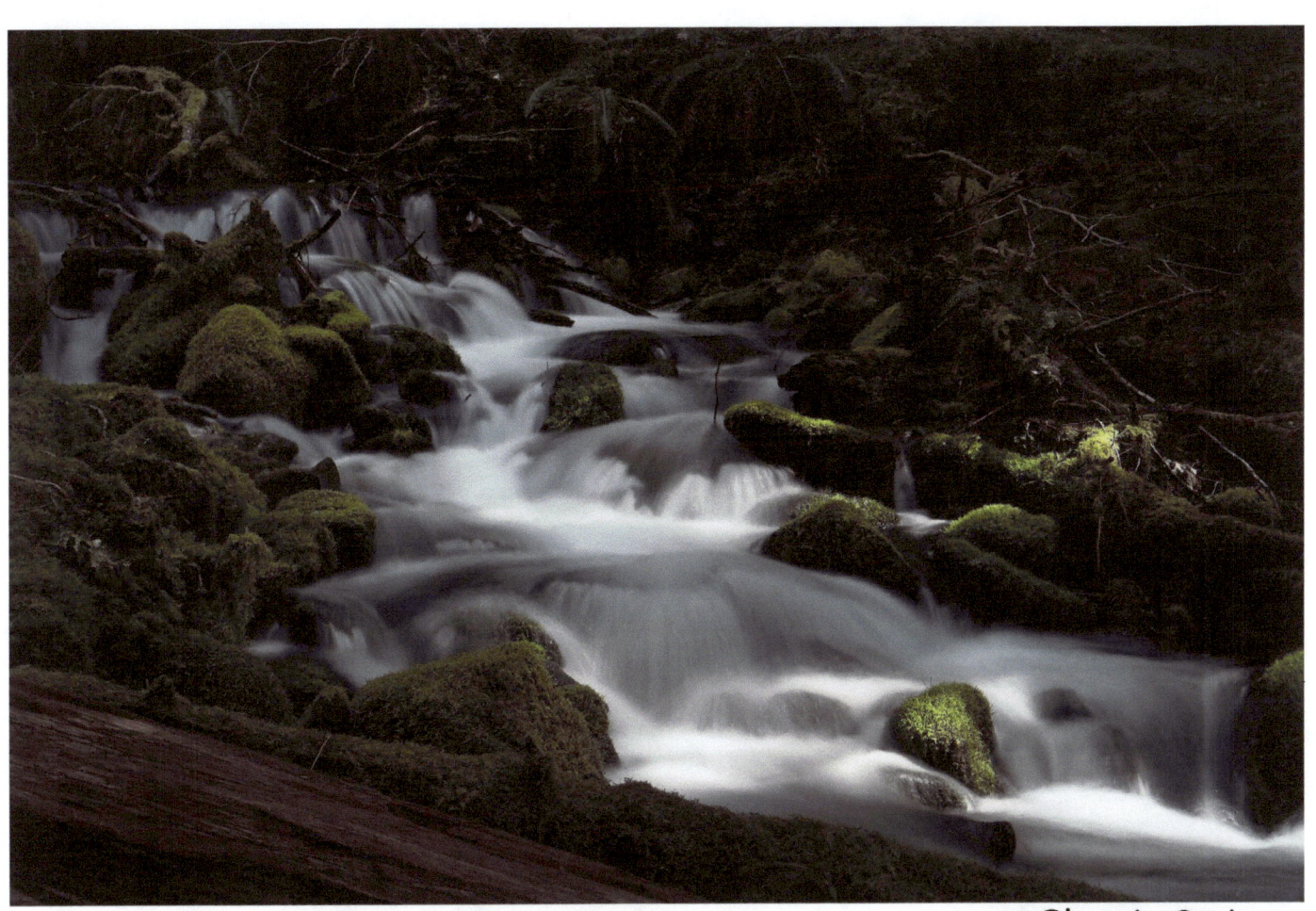

Olympic Spring

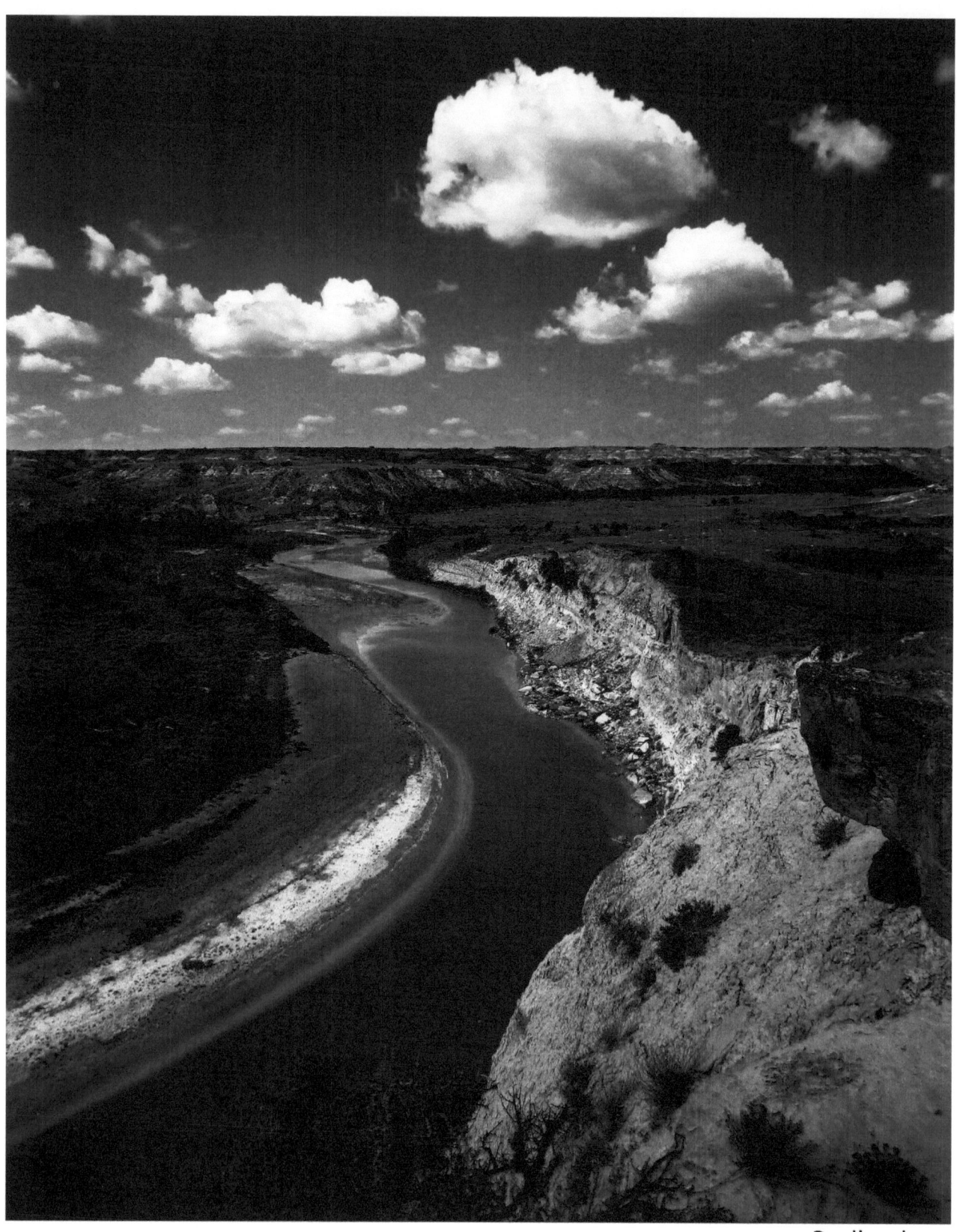

Badlands

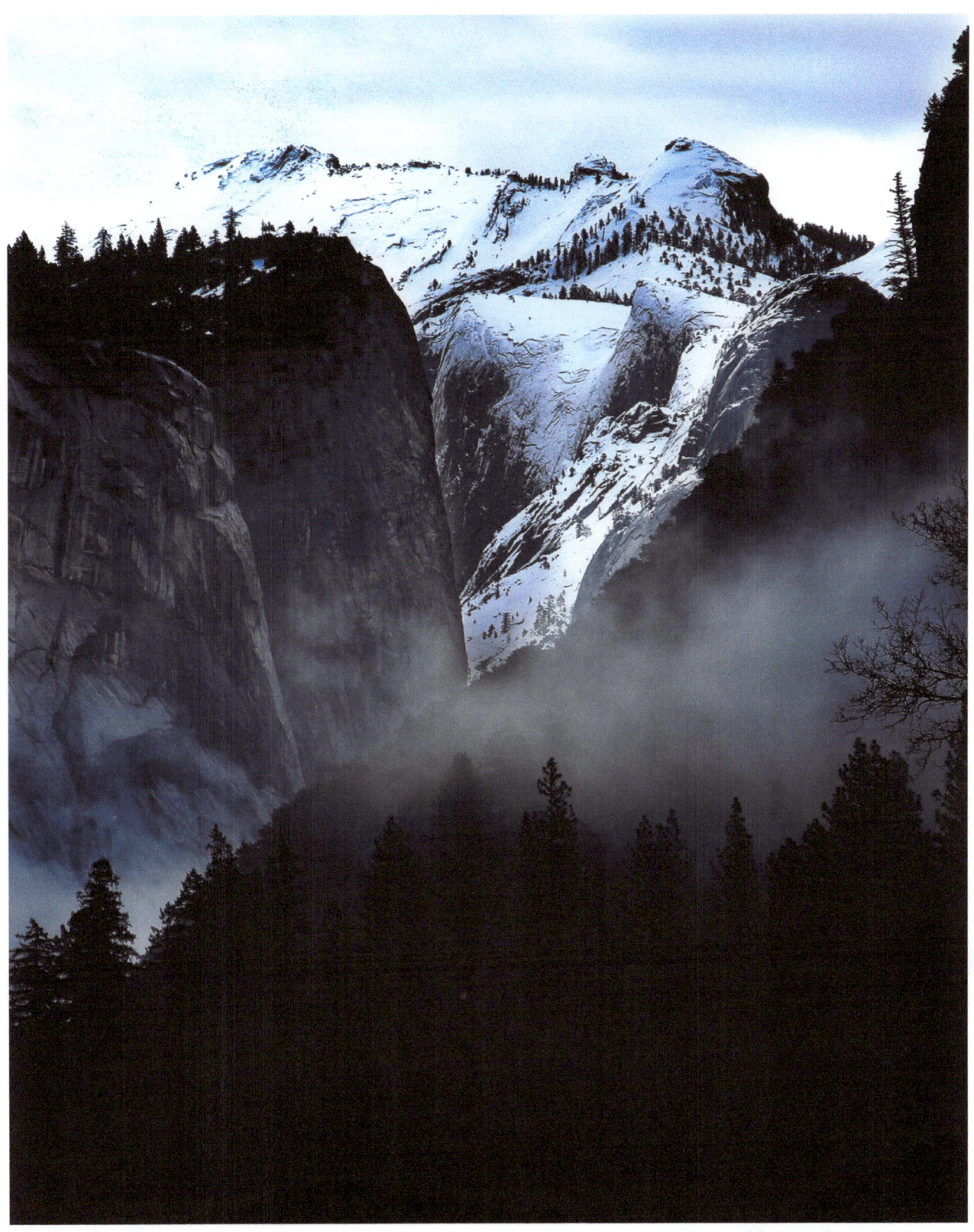

Yosemite Storm

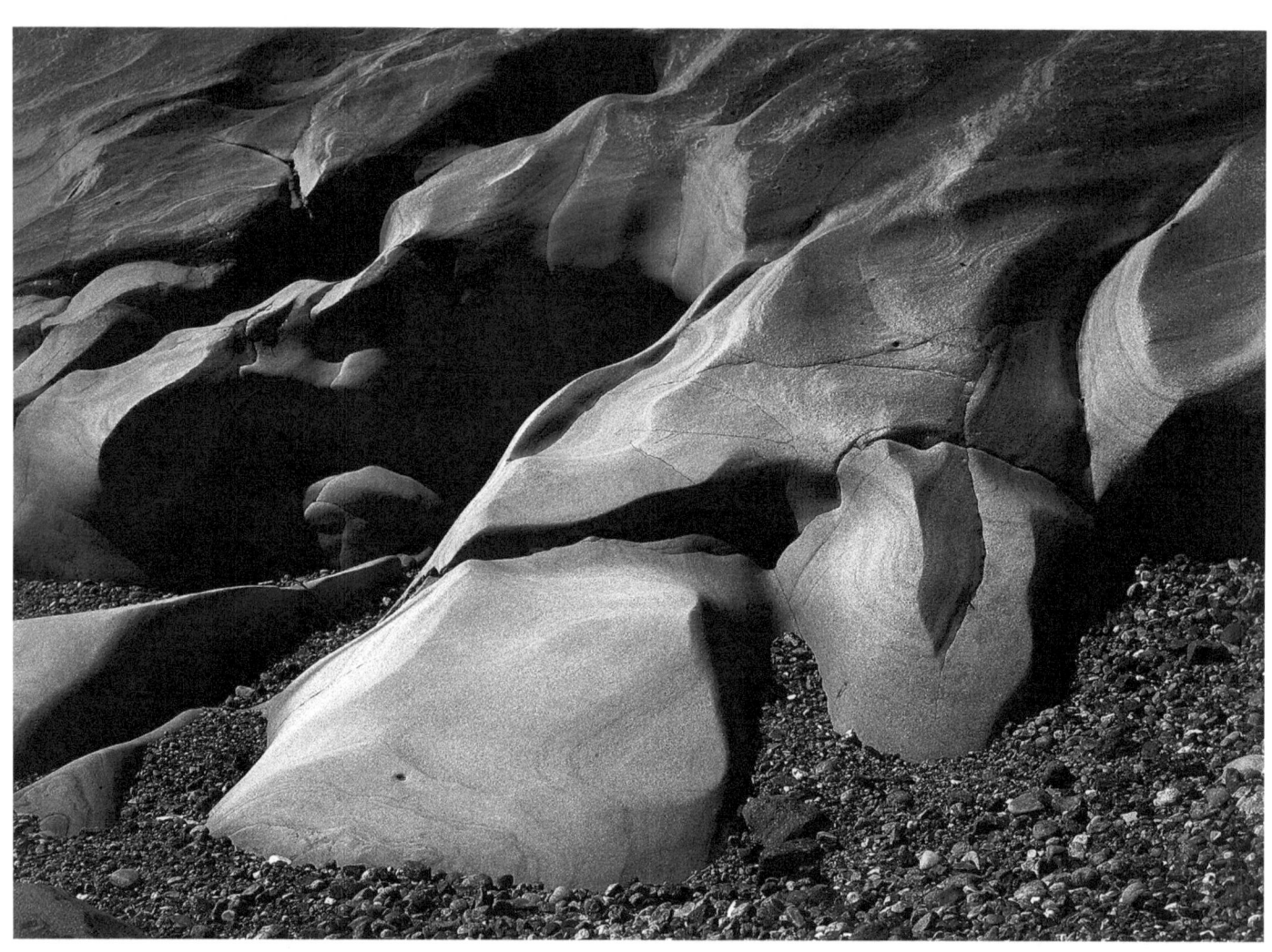

Pt. Lobos Rocks

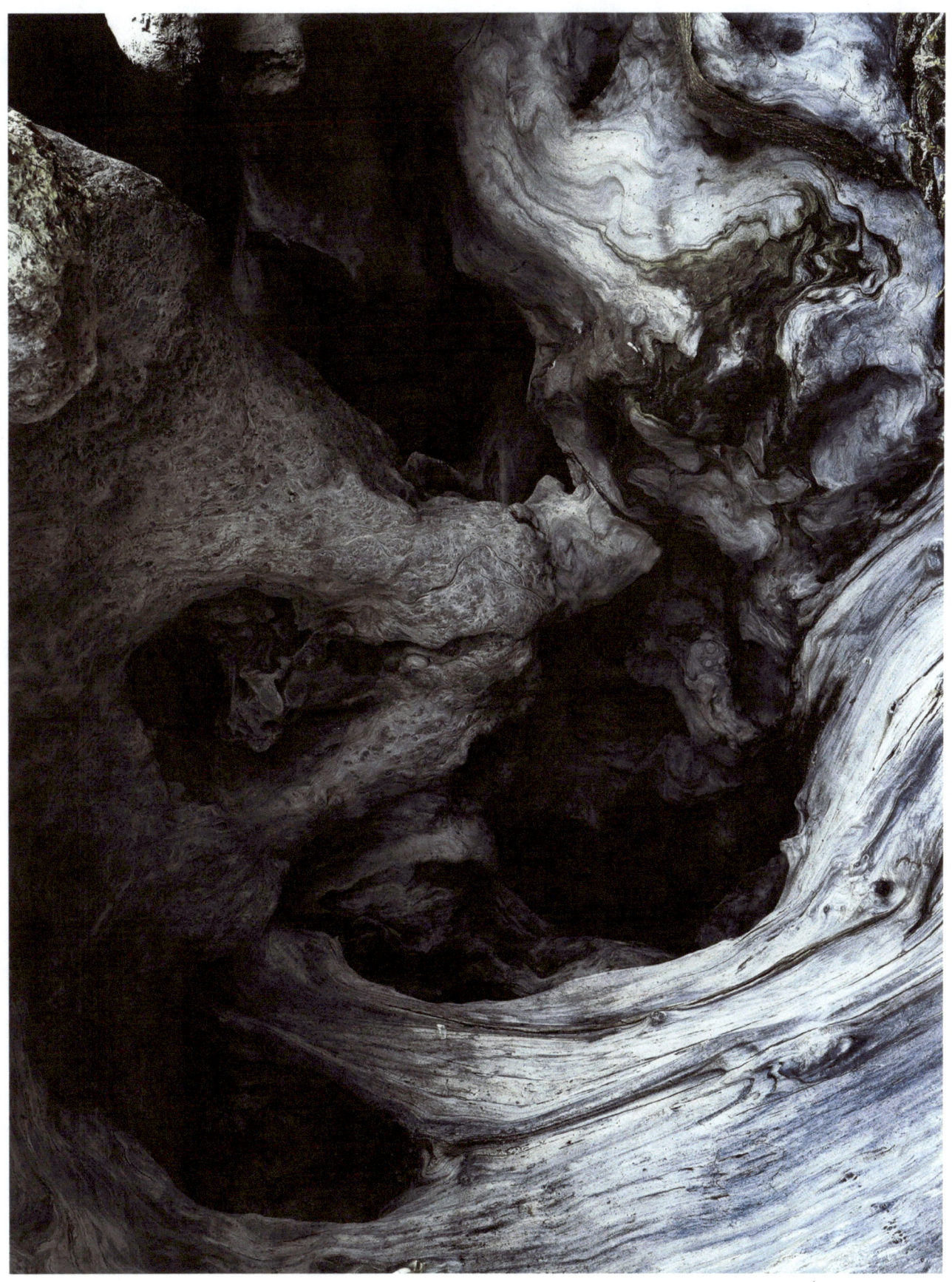

Wood Abstract

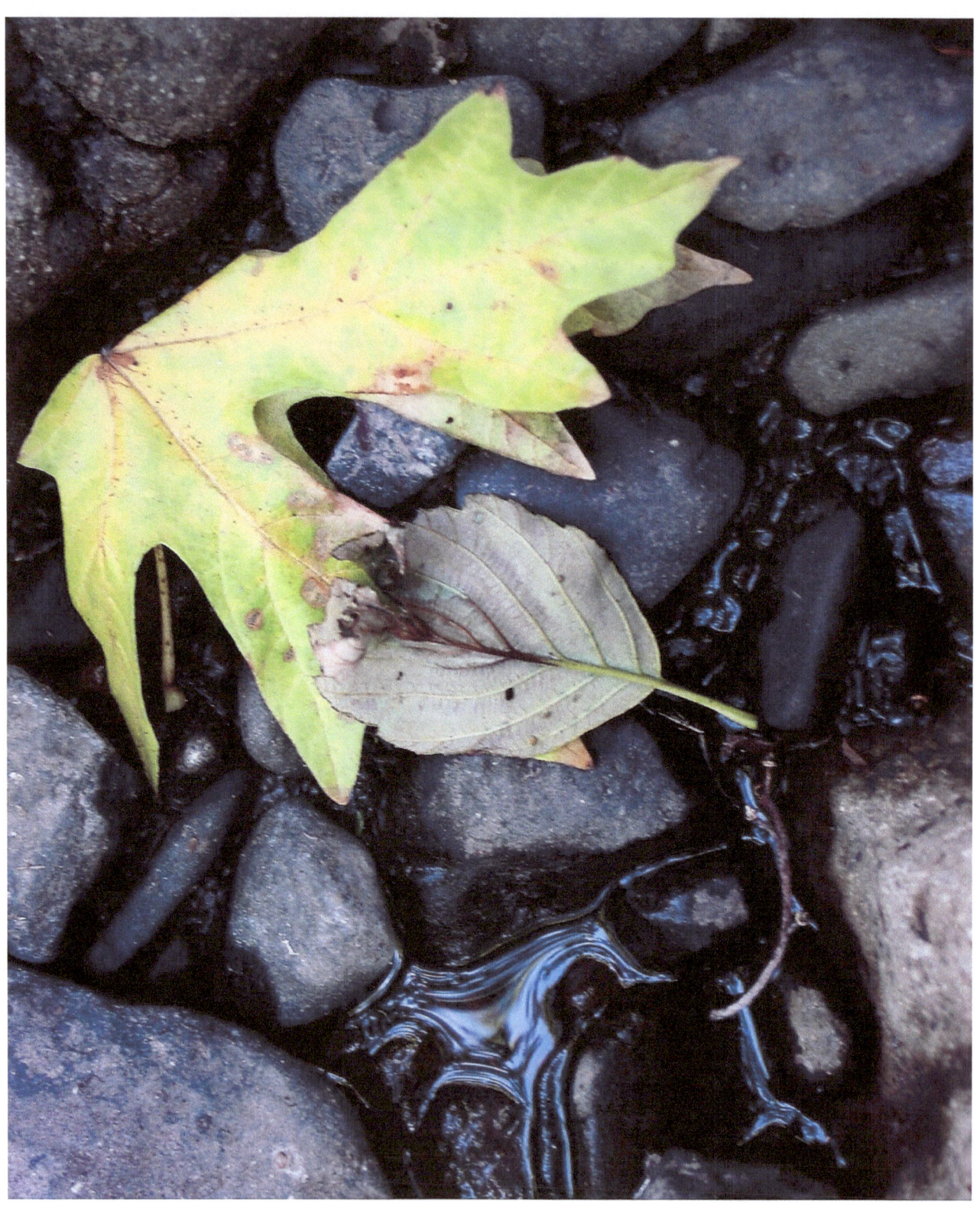

Stream Leaves

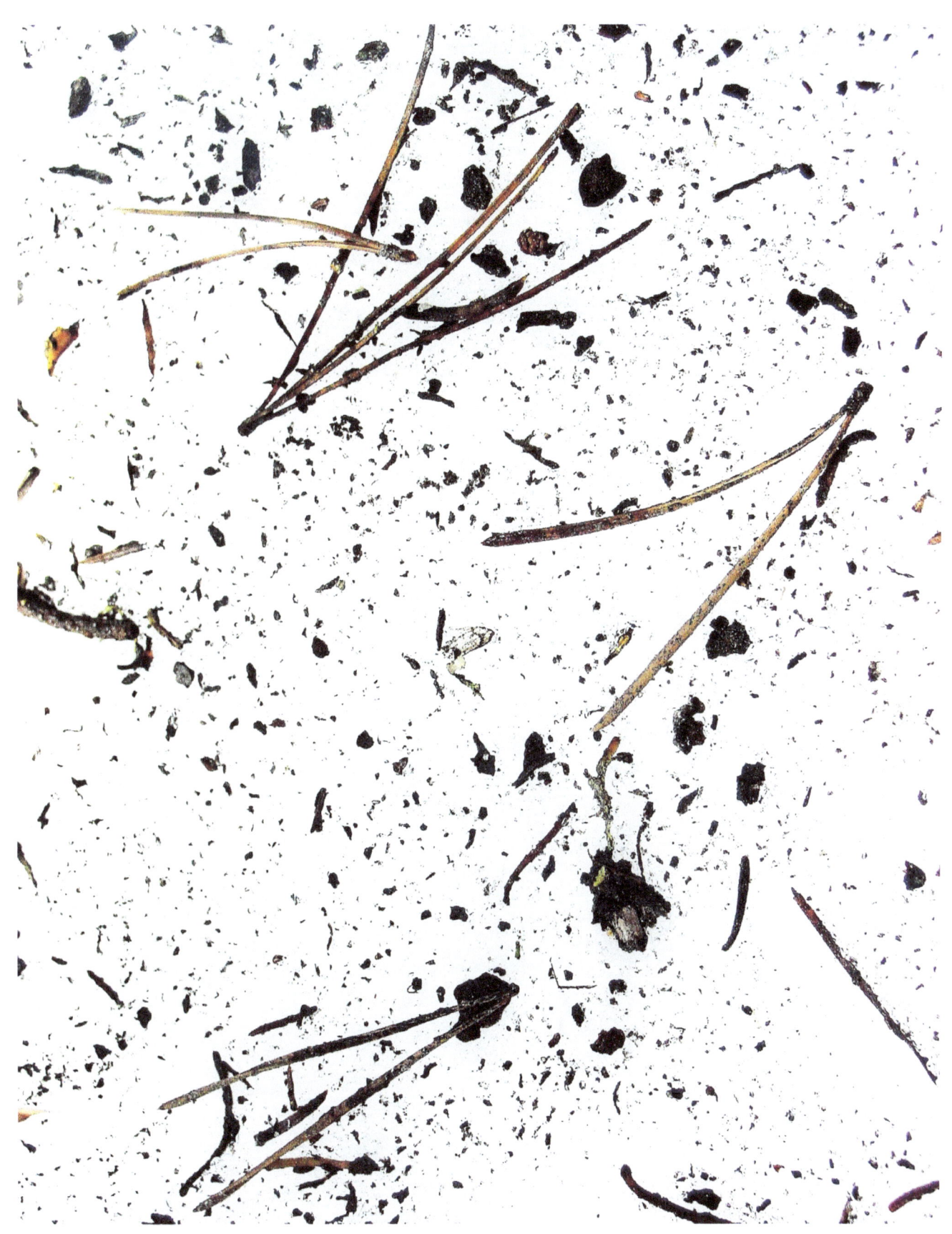

Mt. Lassen Snow

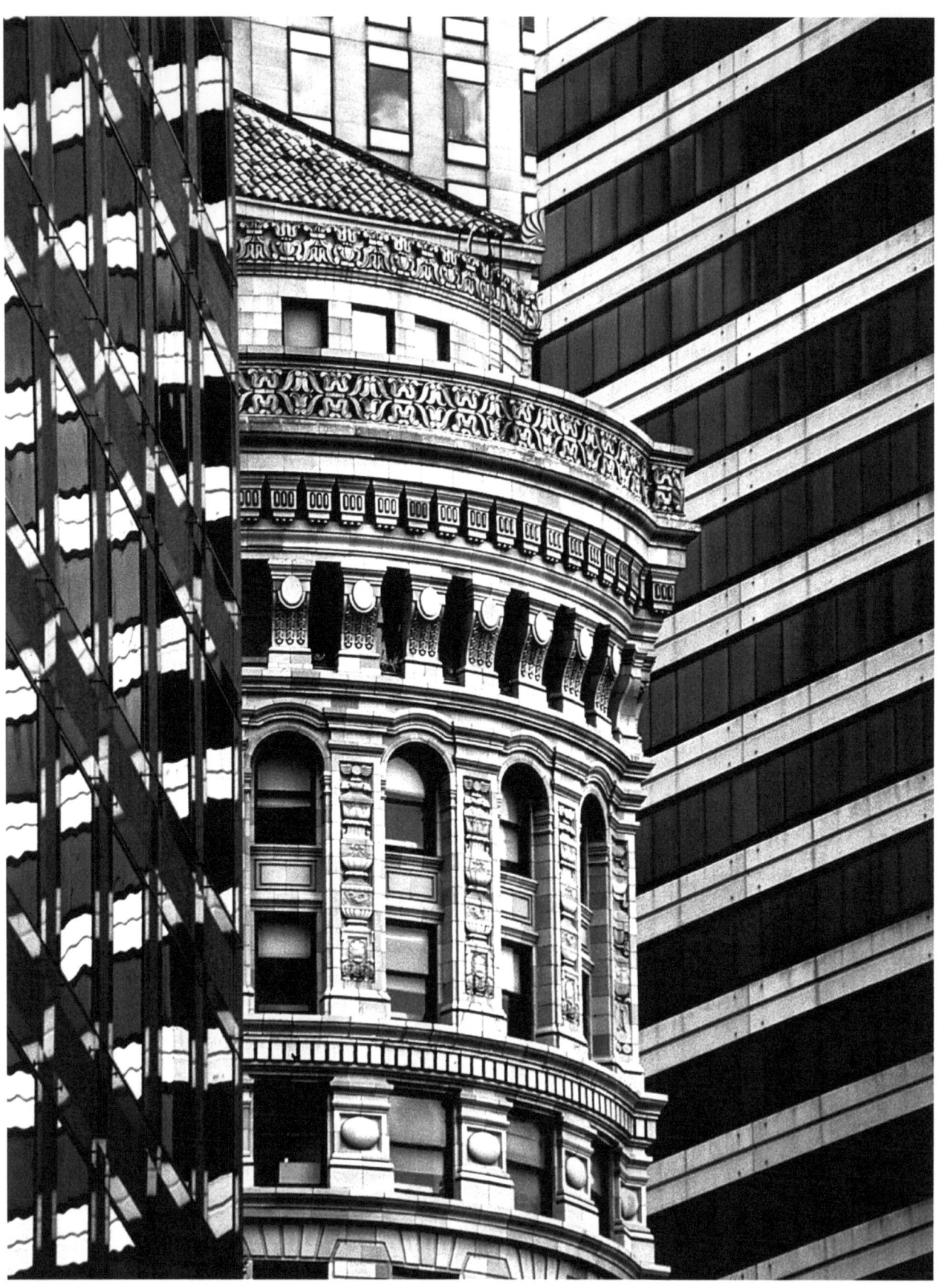

San Francisco I

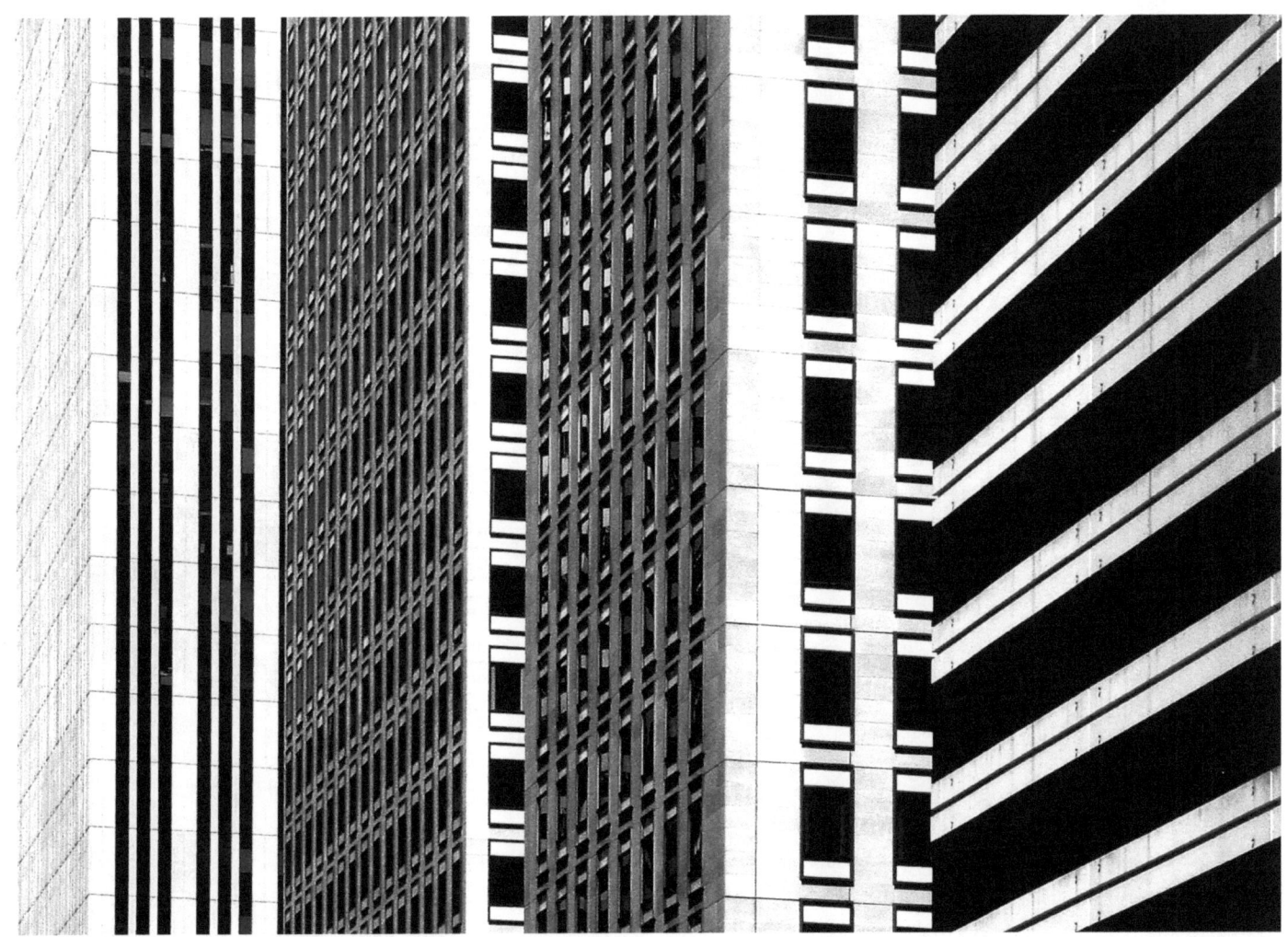
San Francisco II

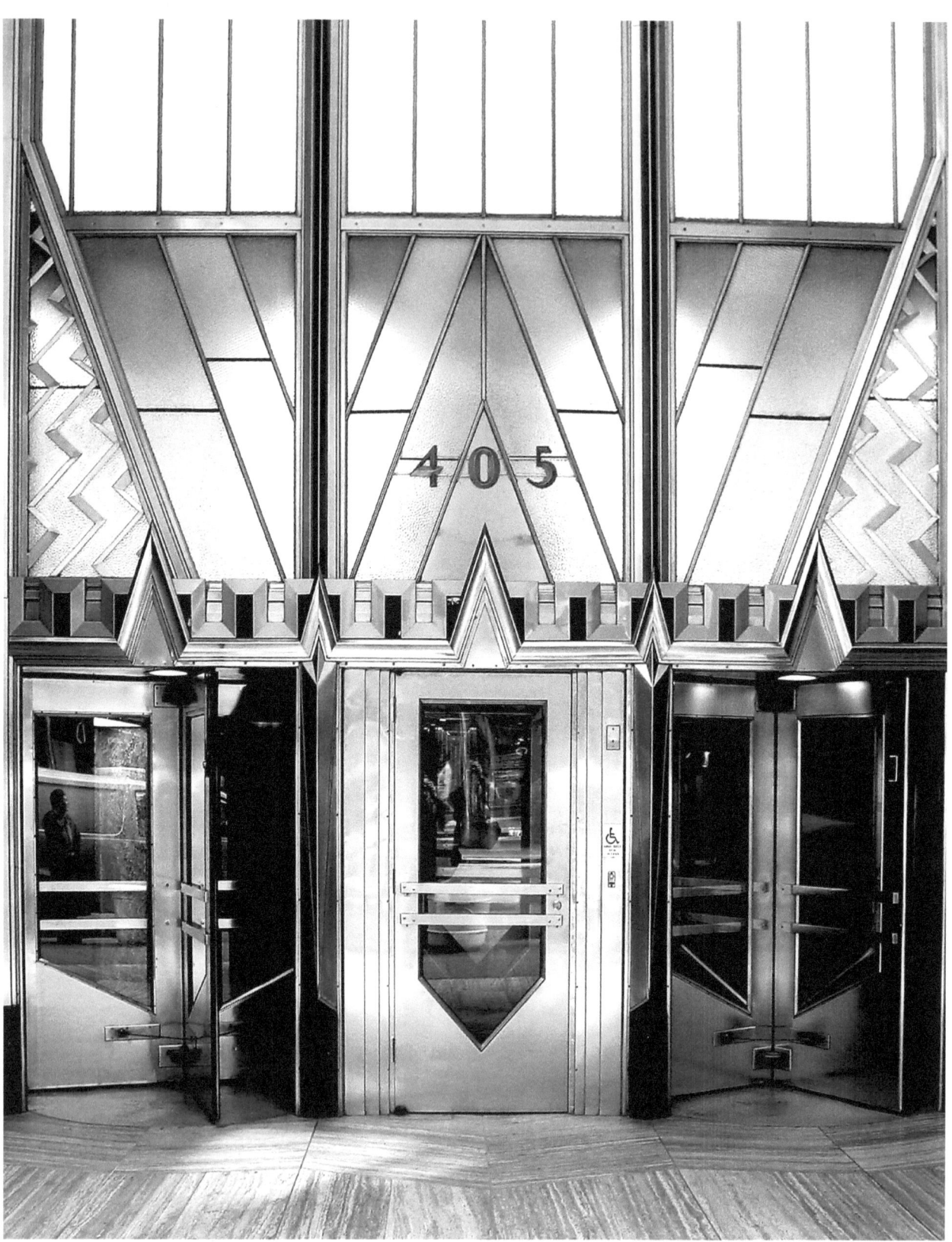

Metropolis

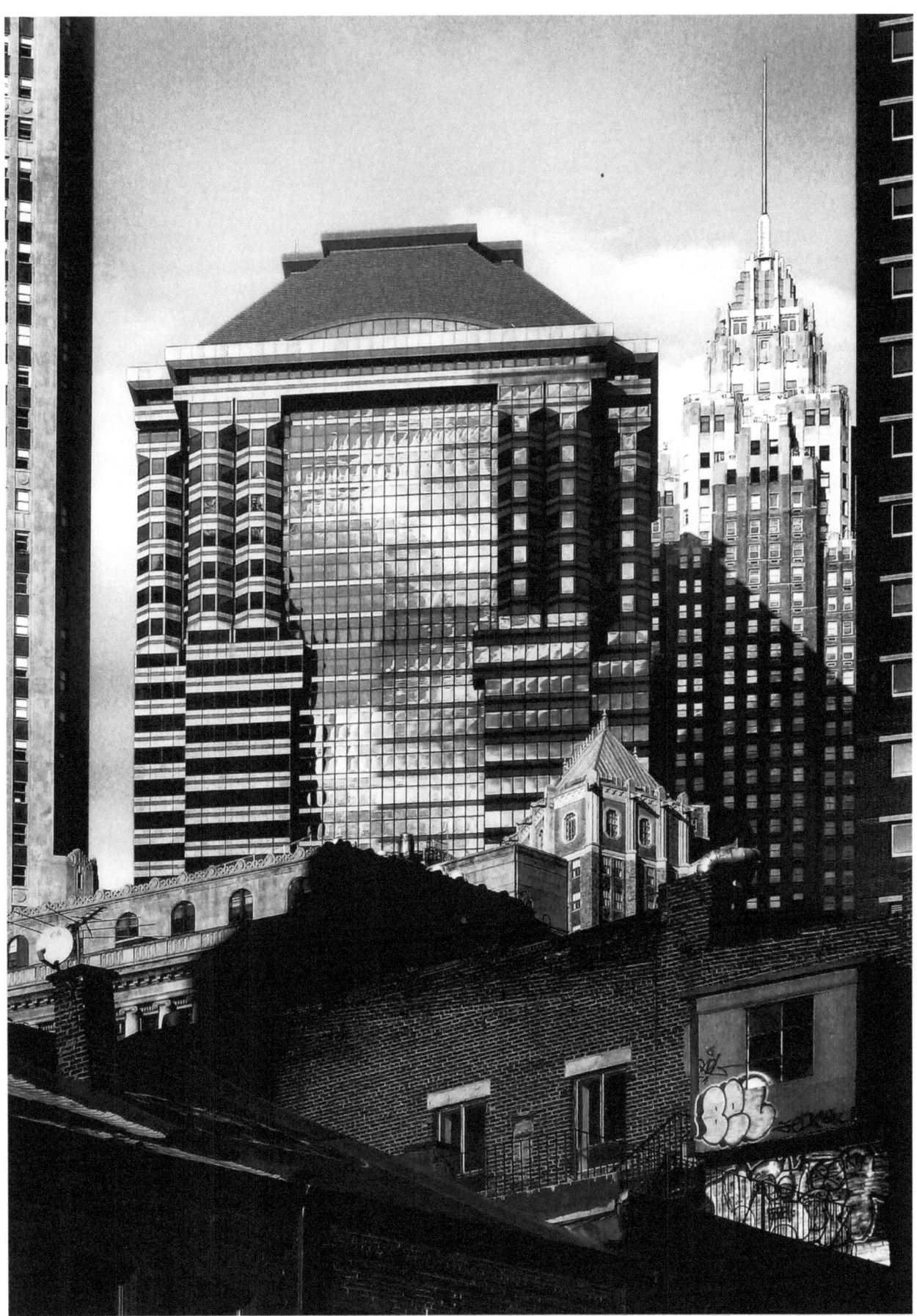

New York Jazz

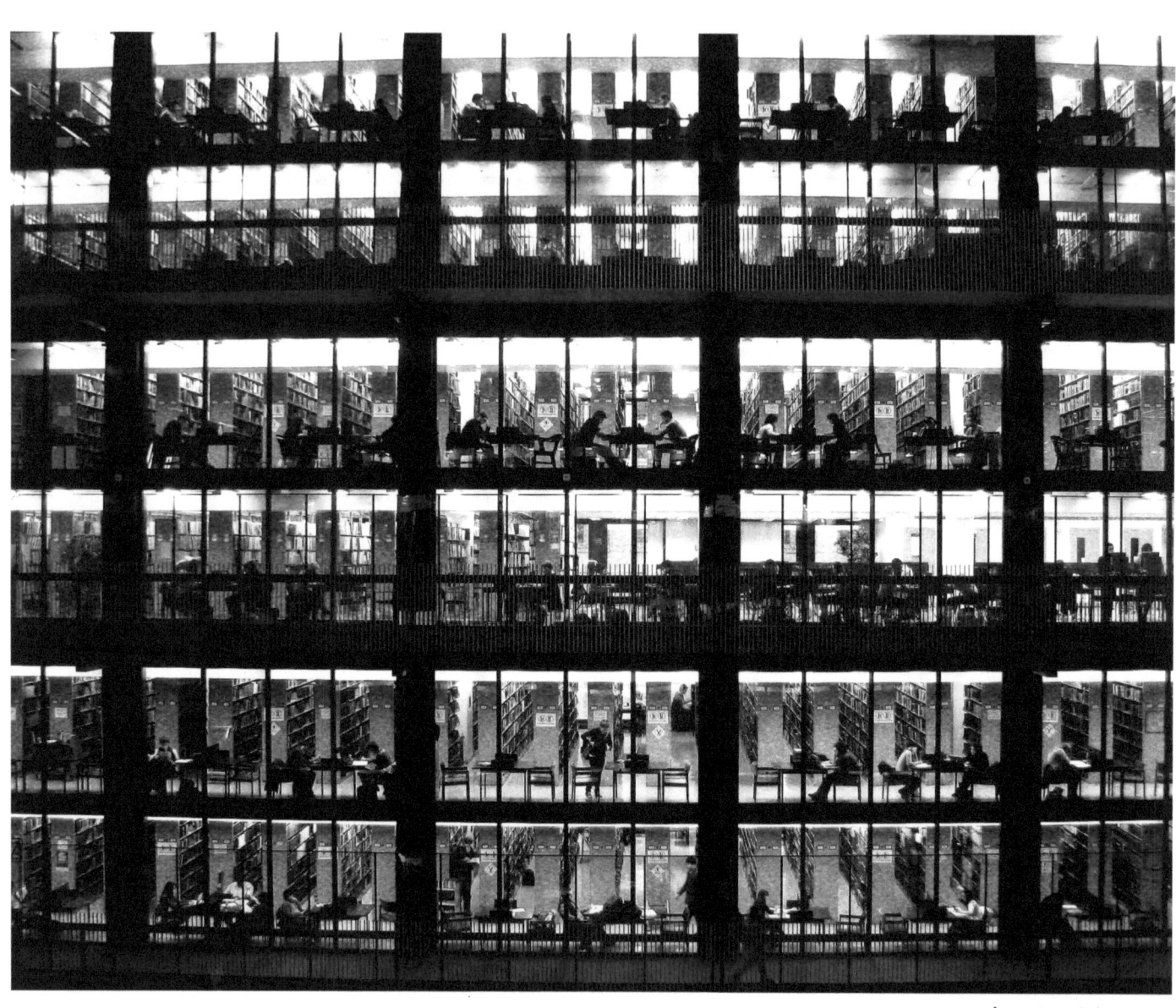

Academia, NYU

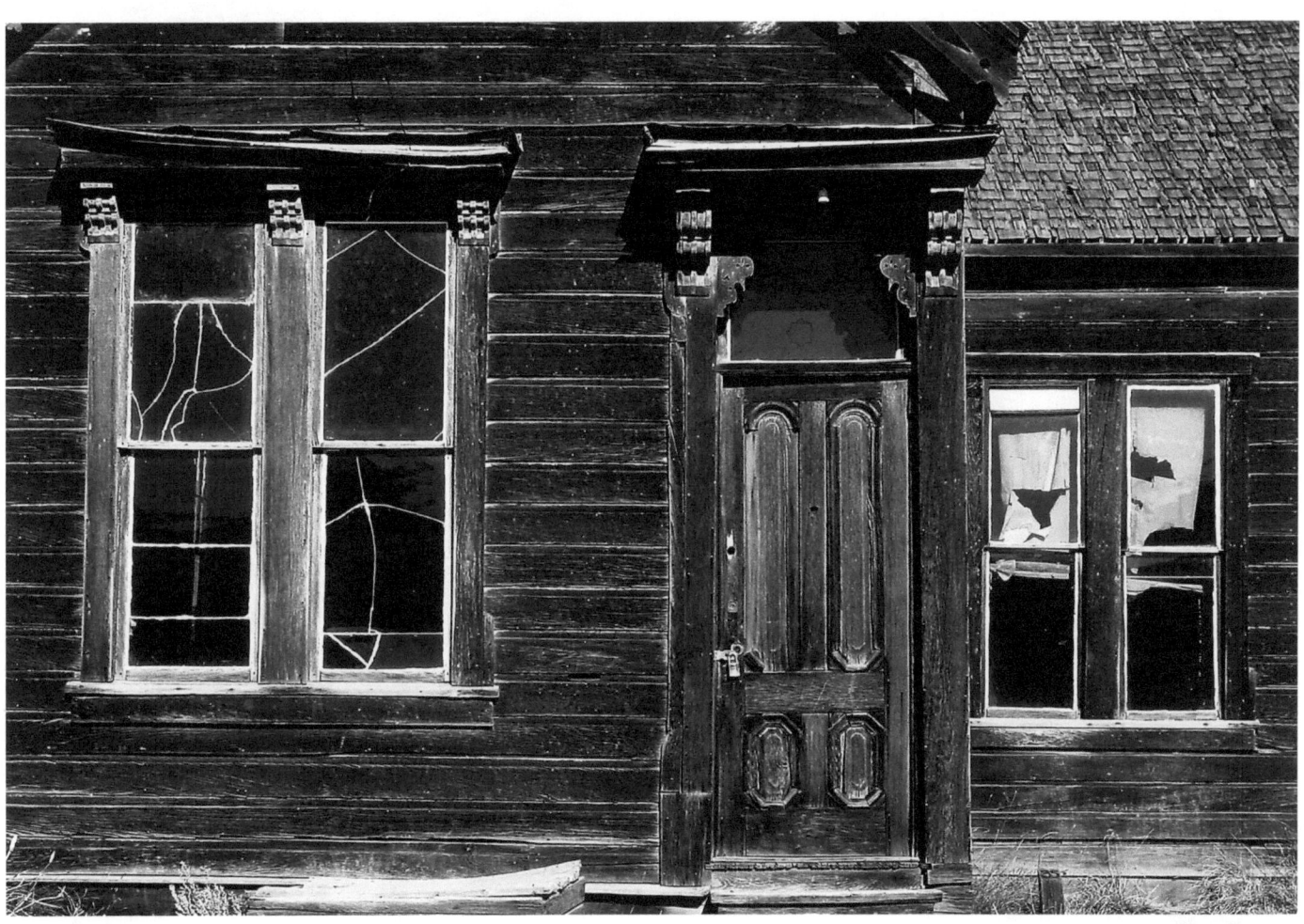

Bodie

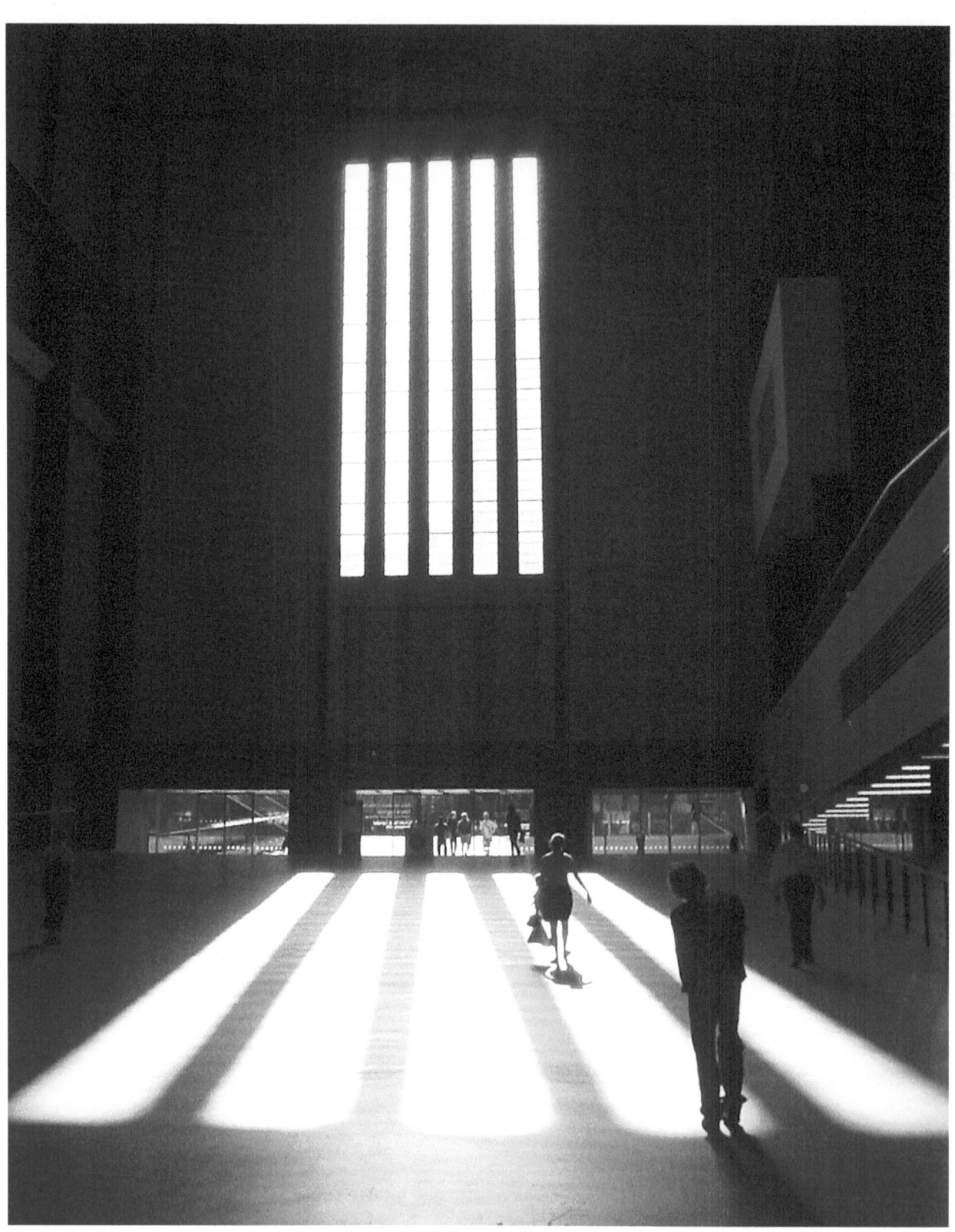

Tate Modern

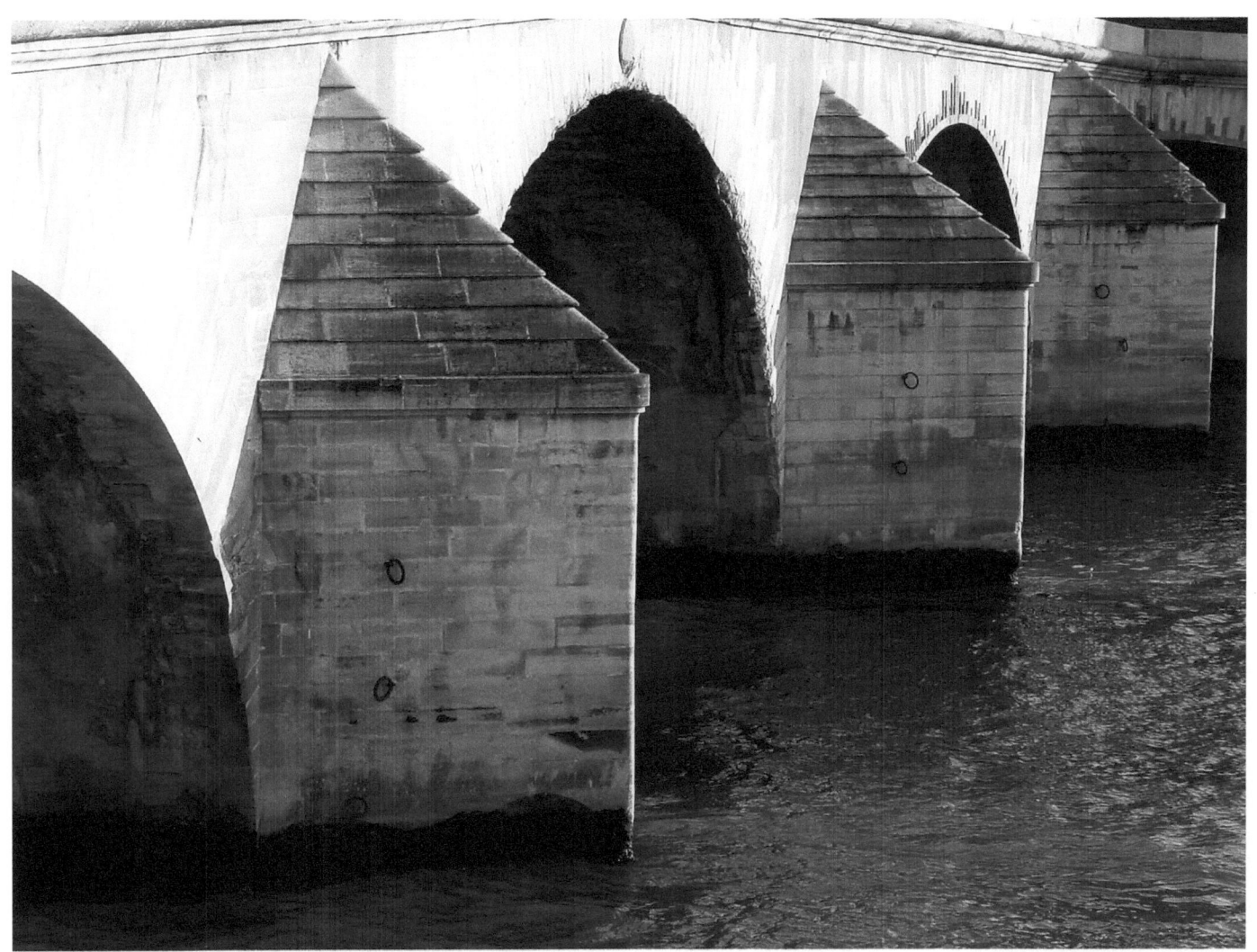

Pont Royale, Paris

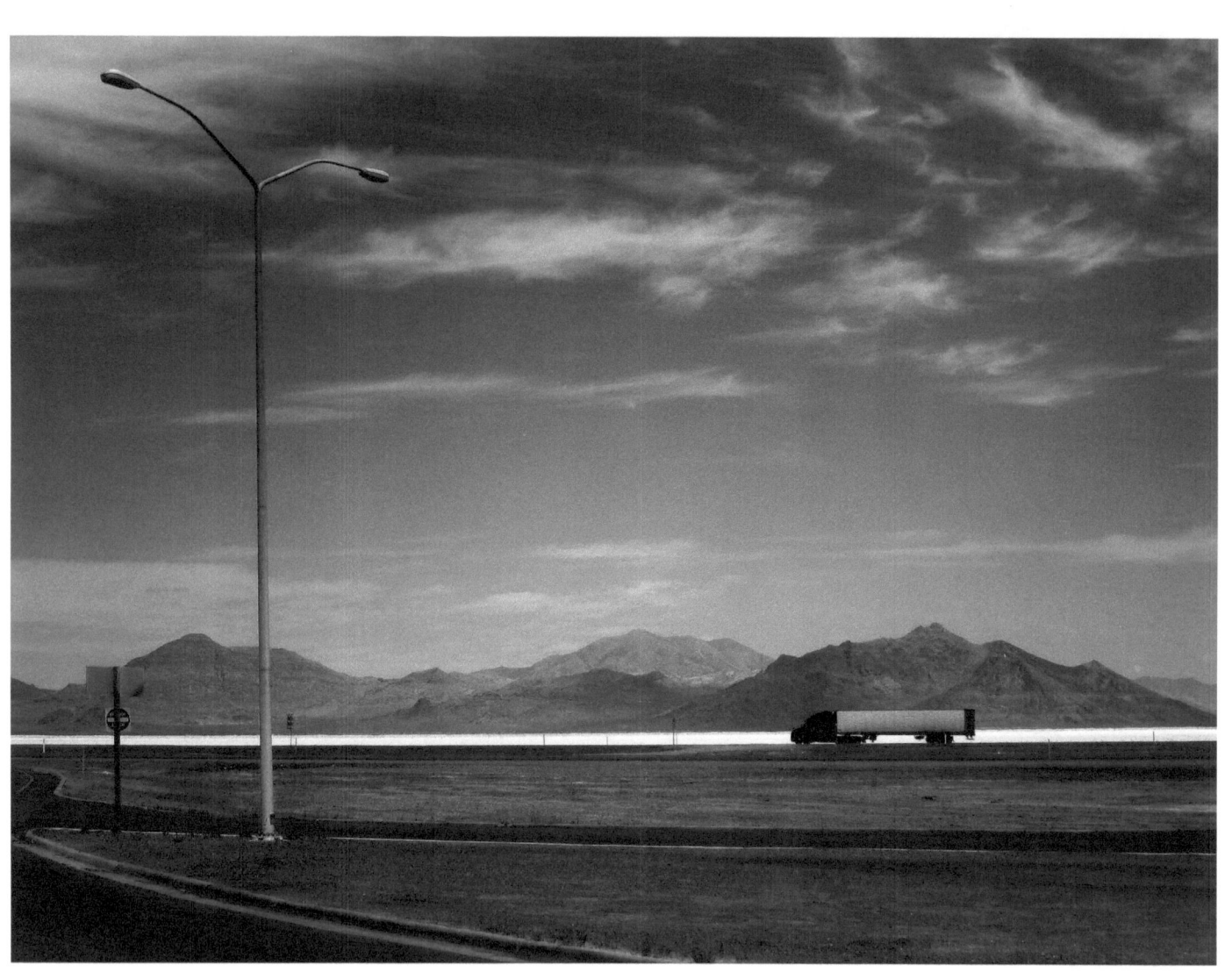

Utah Salt Flats

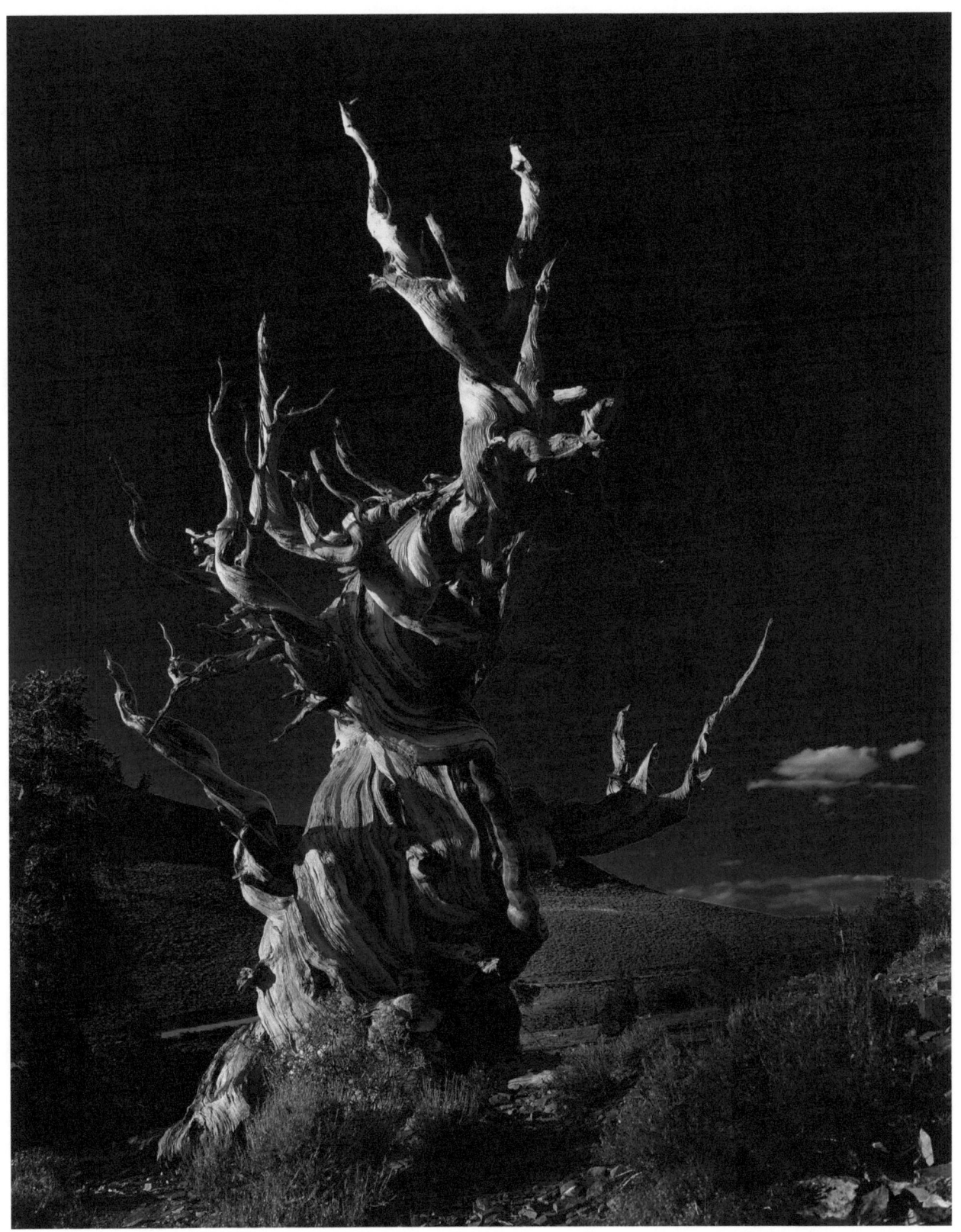

Bristlecone Pine

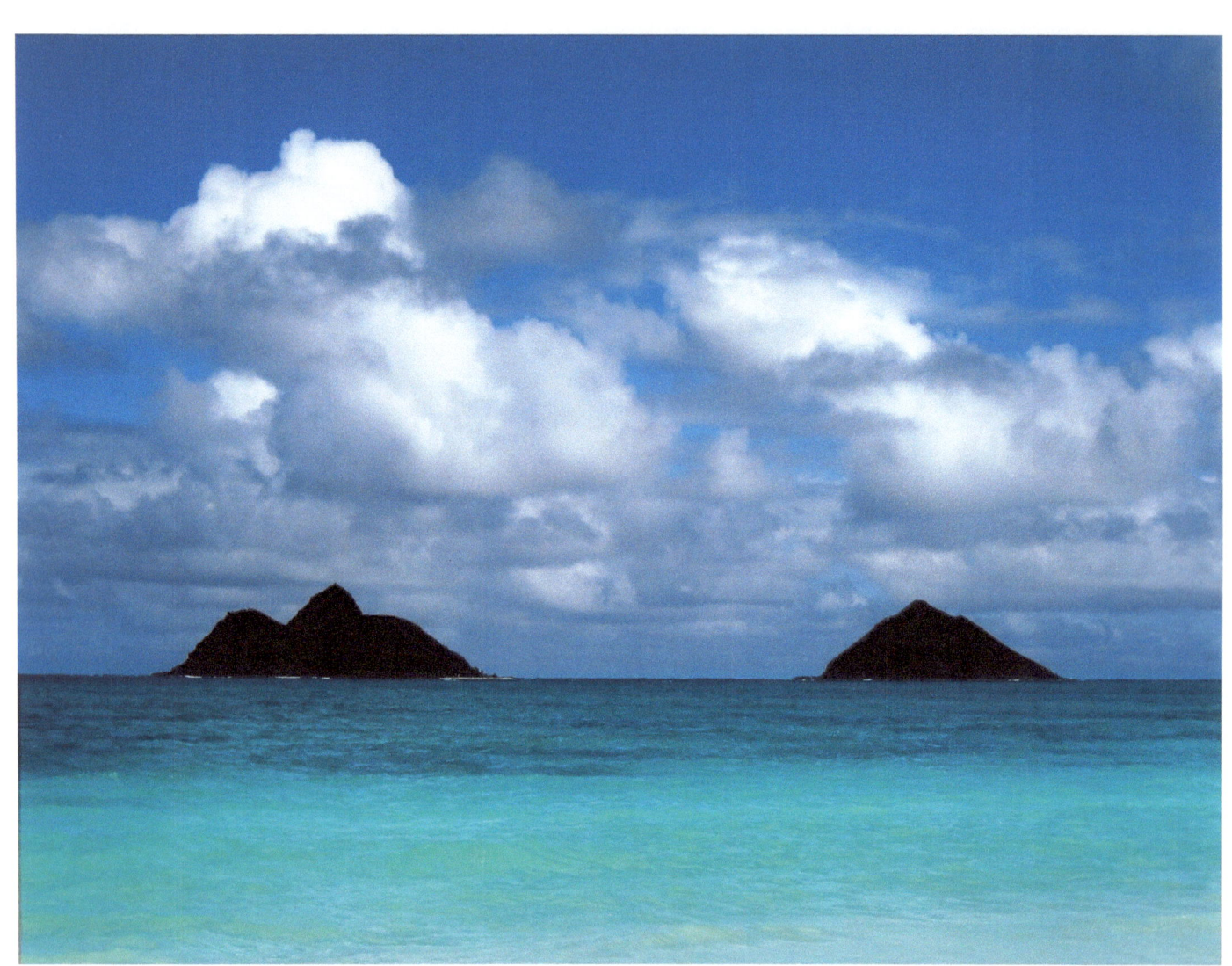

Lanikai

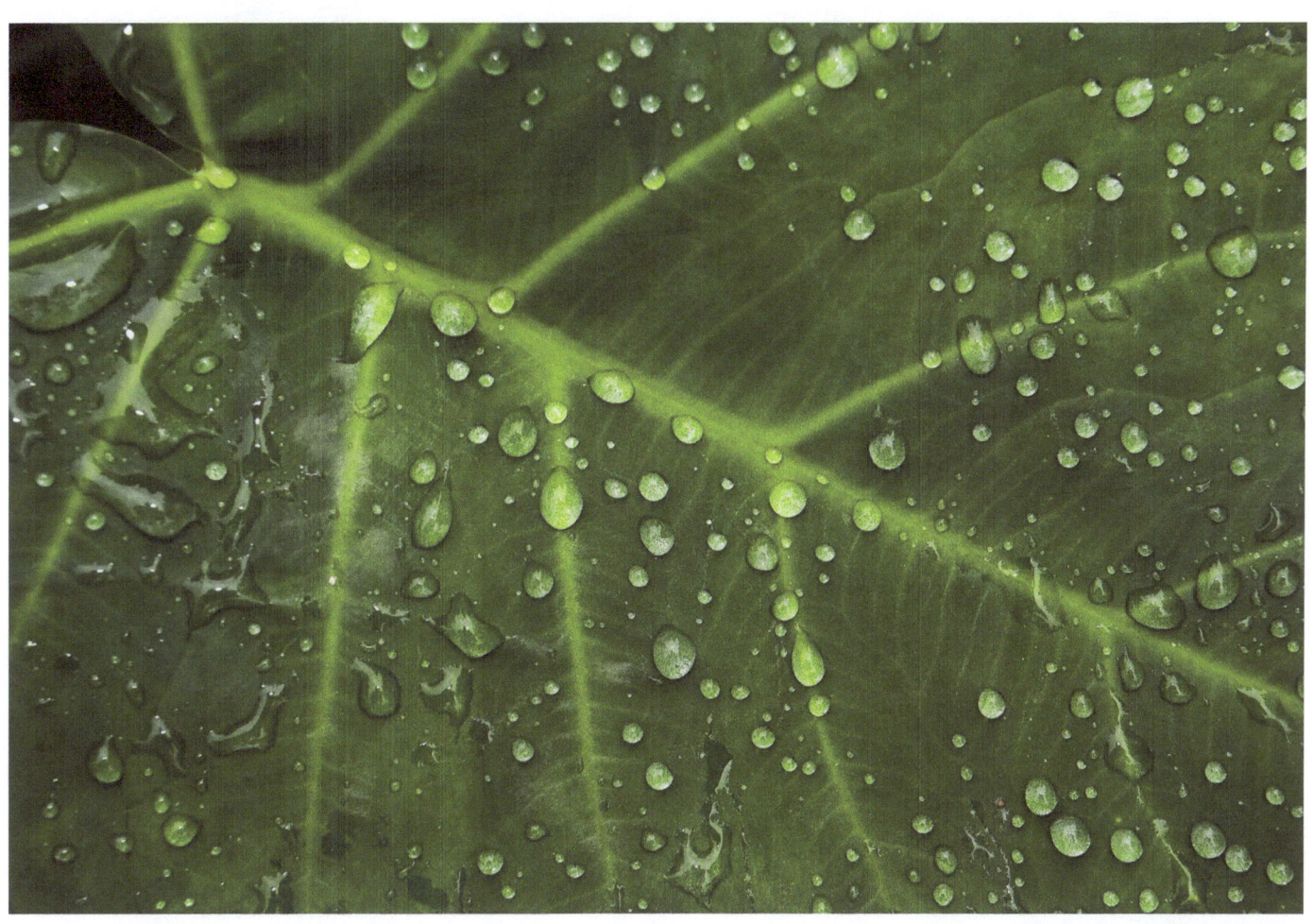

Leaf Drops

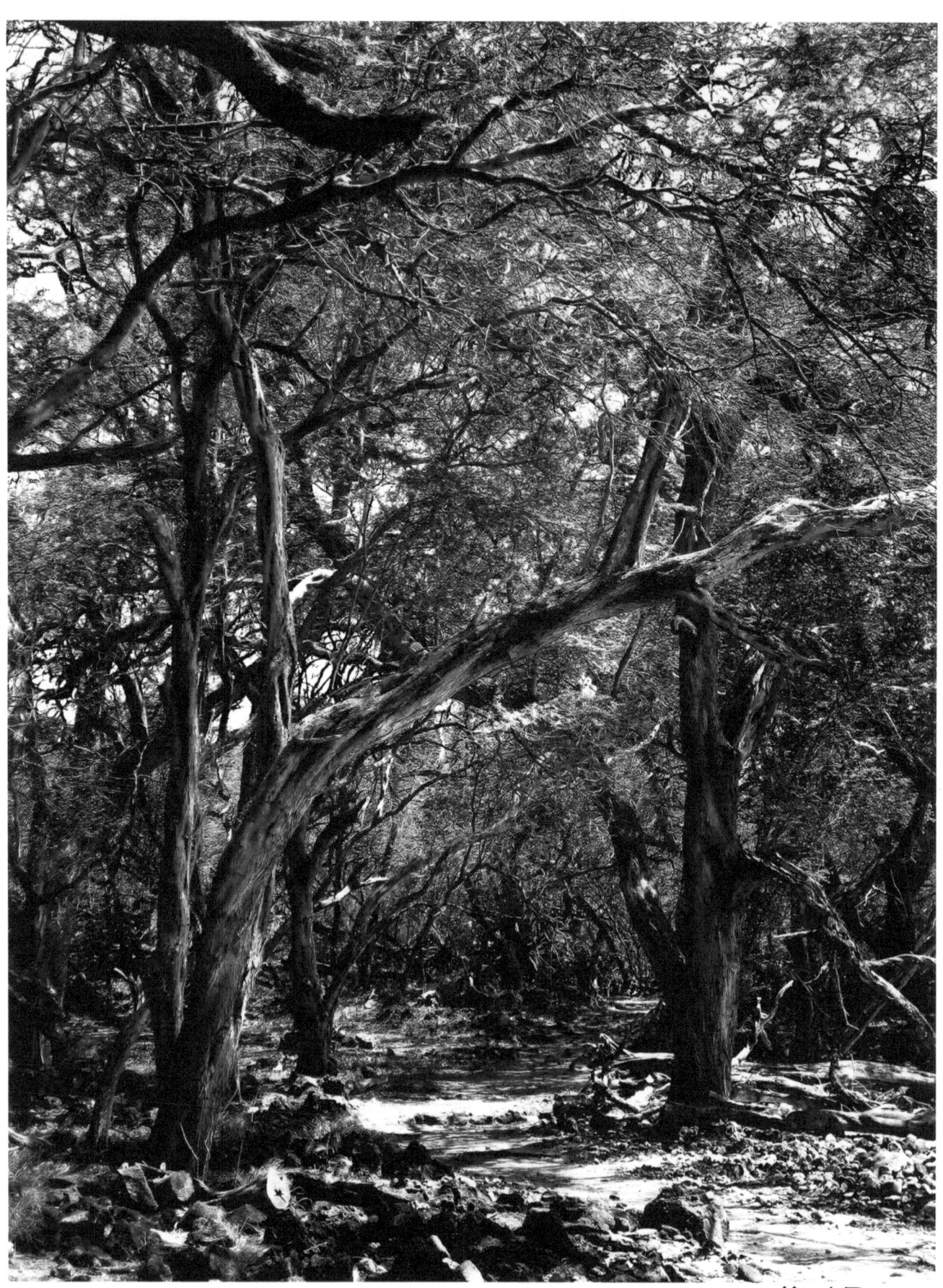

Maui Trees

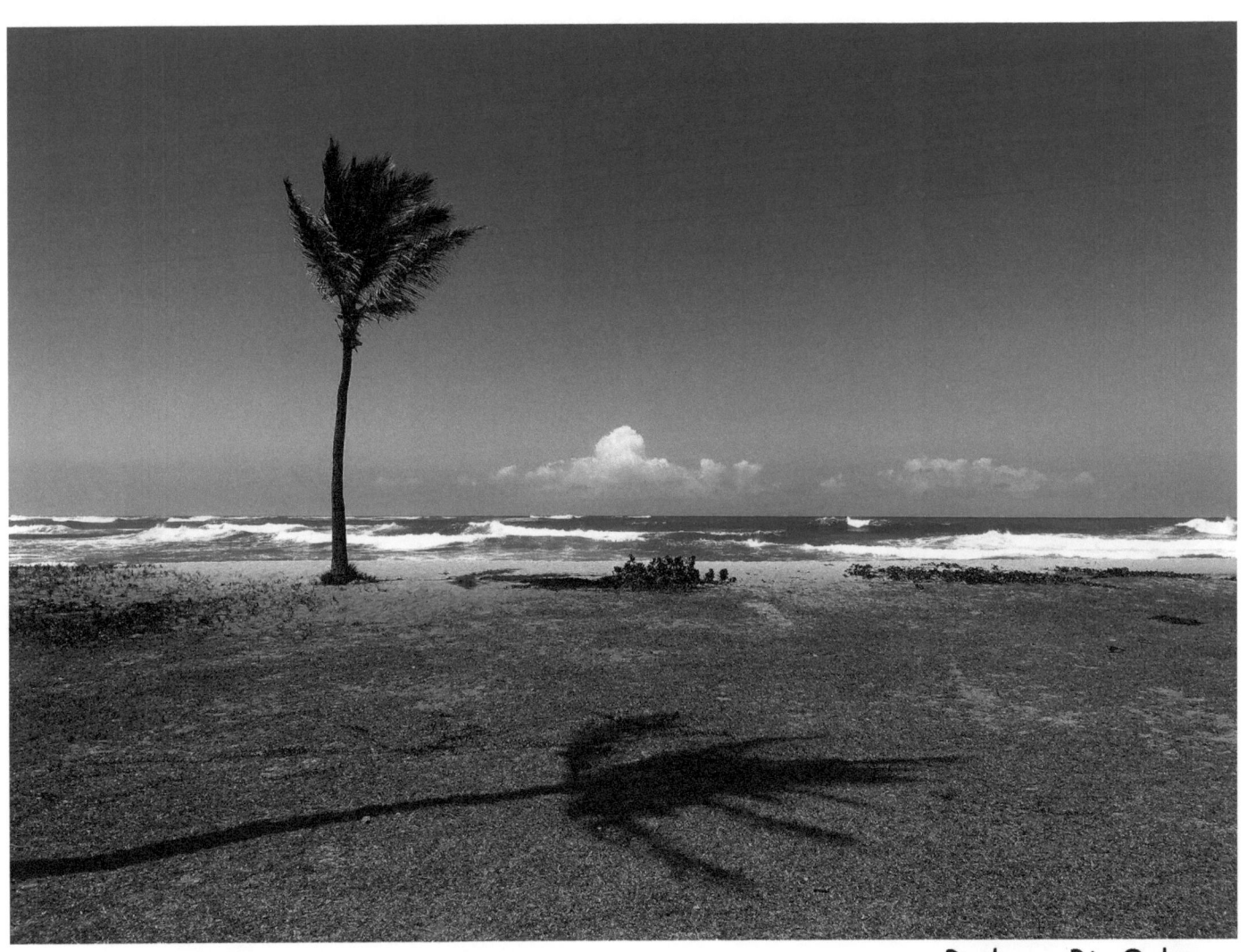

Barbers Pt, Oahu

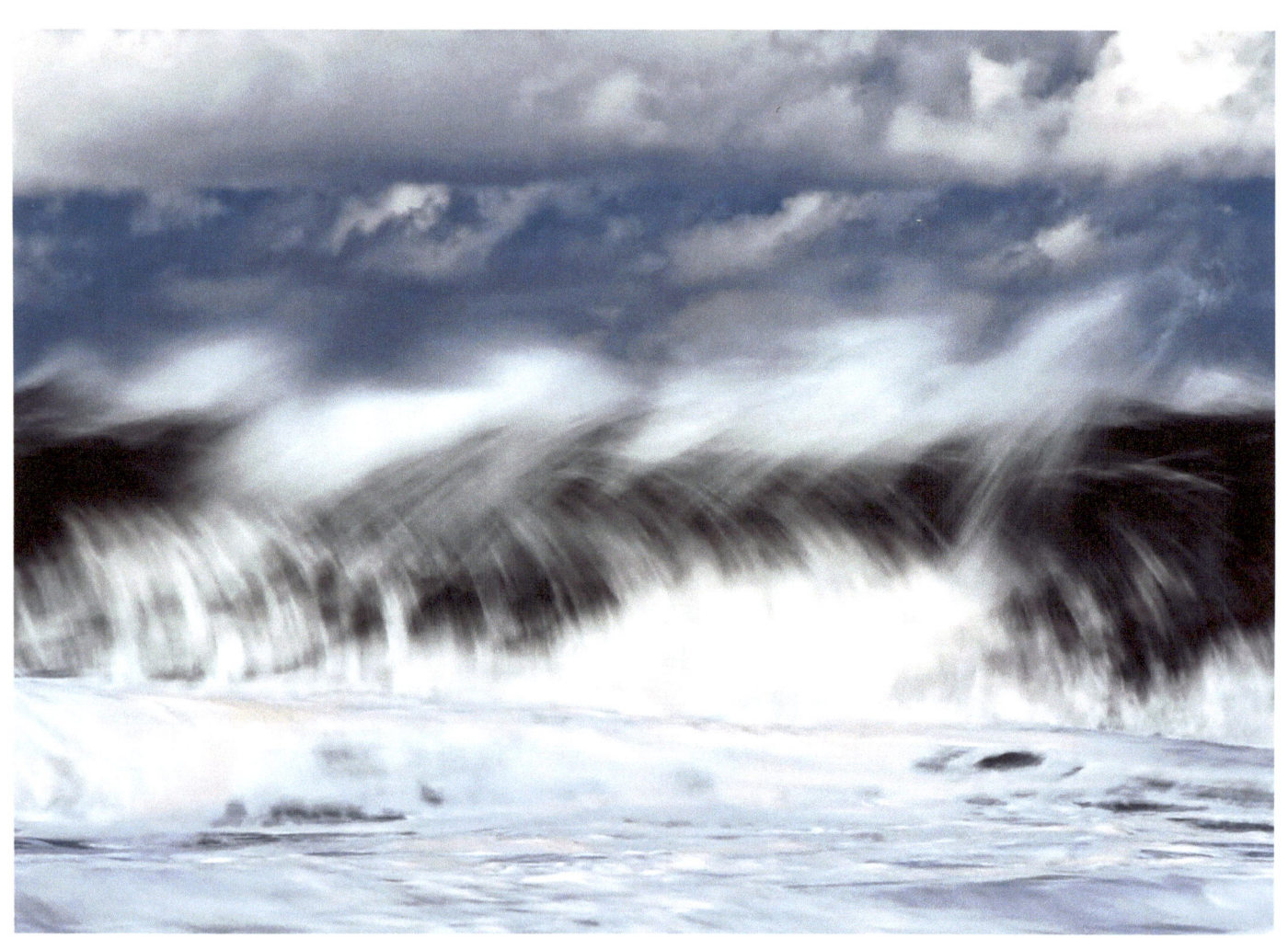

Sunset Beach, Oahu

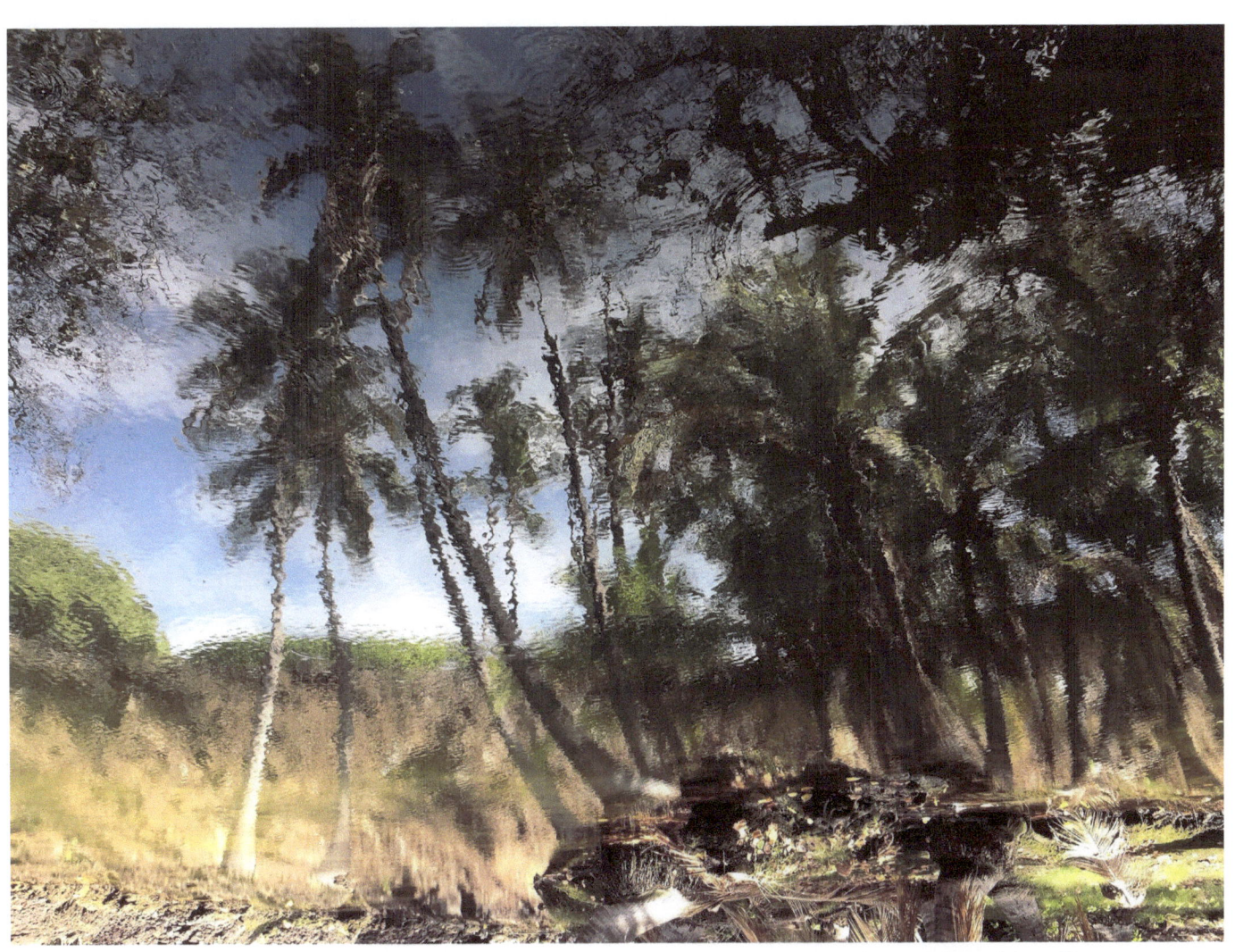

Big Island Reflections

In the Mind's Eye

Thinking of you...

—Art Shimamura

www.ingramcontent.com/pod-product-compliance
Lightning Source LLC
Chambersburg PA
CBHW051103180526
45172CB00002B/757